OBJECTS OF REFLECTION

A Soulful Journey
Through Assemblage

ANNIE
LOCKHART

NORTH
LIGHT
BOOKS

North Light Books
Cincinnati, Ohio
www.mycraftivity.com

14 13 12 11 10 5 4 3 2 1

Distributed in Canada by Fraser Direct

100 Armstrong Avenue

Georgetown, ON, Canada L7G 5S4

Tel: (905) 877-4411

Distributed in the U.K. and Europe by David & Charles

Brunel House, Newton Abbot, Devon, TQ12 4PU, England

Tel: (+44) 1626 323200, Fax: (+44) 1626 323319

Email: postmaster@davidandcharles.co.uk

fw
media
an imprint of F+W Media, Inc.
www.fwmedia.com

Distributed in Australia by Capricorn Link

P.O. Box 704, S. Windsor, NSW 2756 Australia

Tel: (02) 4577-3555

Library of Congress Cataloging-in-Publication Data

Lockhart, Annie.

 Objects of reflection / Annie Lockhart. — 1st ed.

 p. cm.

 Includes index.

 ISBN-13: 978-1-60061-331-9 (pbk. : alk. paper)

 ISBN-10: 1-60061-331-4 (pbk. : alk. paper)

 1. Handicraft. 2. Assemblage (Art) I. Title.

TT880.L6354 2010

745.5-dc22

 2009033374

EDITOR: TONIA DAVENPORT

DESIGNER: KELLY O'DELL

PRODUCTION COORDINATOR: GREG NOCK

PHOTOGRAPHERS: CHRISTINE POLOMSKY, RIC DELIANTONI

PHOTO STYLIST: JAN NICKUM

DEDICATION

To my five amazing children: Haley, I love and adore your heart. You have always accepted others, leaving no one on the sidelines. That is a true gift! Megan, you are forever my beautiful blue-eyed angel—calm spirit, genuine heart, loving nature. Heath, I don't know how we could've ever made it without your humor, wit and dimples! You are my sweetheart. Kelcee, you are my snuggly, free-spirited, kitchen-dancin' boo baby. Remember you said you'd always live next door to me! Dane, you are filled with compassion, honor and true kindness. Your calm calms me.

My life has been forever filled with love, laughter and lessons with y'all at its center. I am beyond grateful for each of your unique gifts, the friendship and love you have for one another, and the way y'all love me. Each one of you has brought so much joy into our family. I love you more than words can ever express. Mmmmm!!!!

To my four darling grandchildren: Kayla Brooke, Kassidy Paige, Kolton Shawn and Laynee Jane; you are the little loves of my life! Mmmmm!!!! I'm one lucky Nana! I love y'all so much!

ACKNOWLEDGMENTS

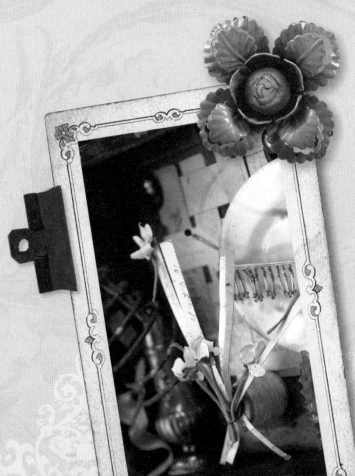

Thank you to my family and friends, near and far, old and new, for accepting me just as I am, with all of my weird collections and quirky ways.

Thank you, Dan; you have been so supportive over the years in everything that I've conjured up in this heart of mine. Thank you for all of your sweat equity in helping me build my creative dreams.

I'd like to take this opportunity to thank everyone at North Light who added their touch of creativity into the making of this book.

And last but not least, I'd especially like to thank Tonia Davenport, my editor, for seeing something unique in my work that might just inspire others. Thank you for your vision and hard work to make this book a dream-come-true for me.

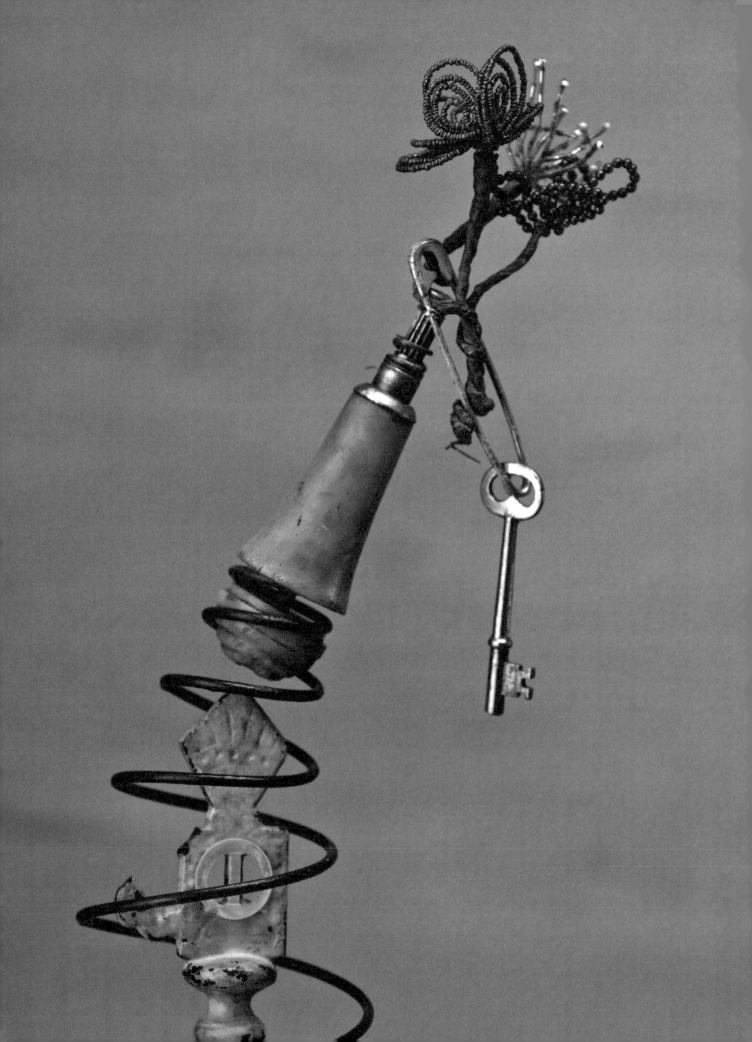

CONTENTS

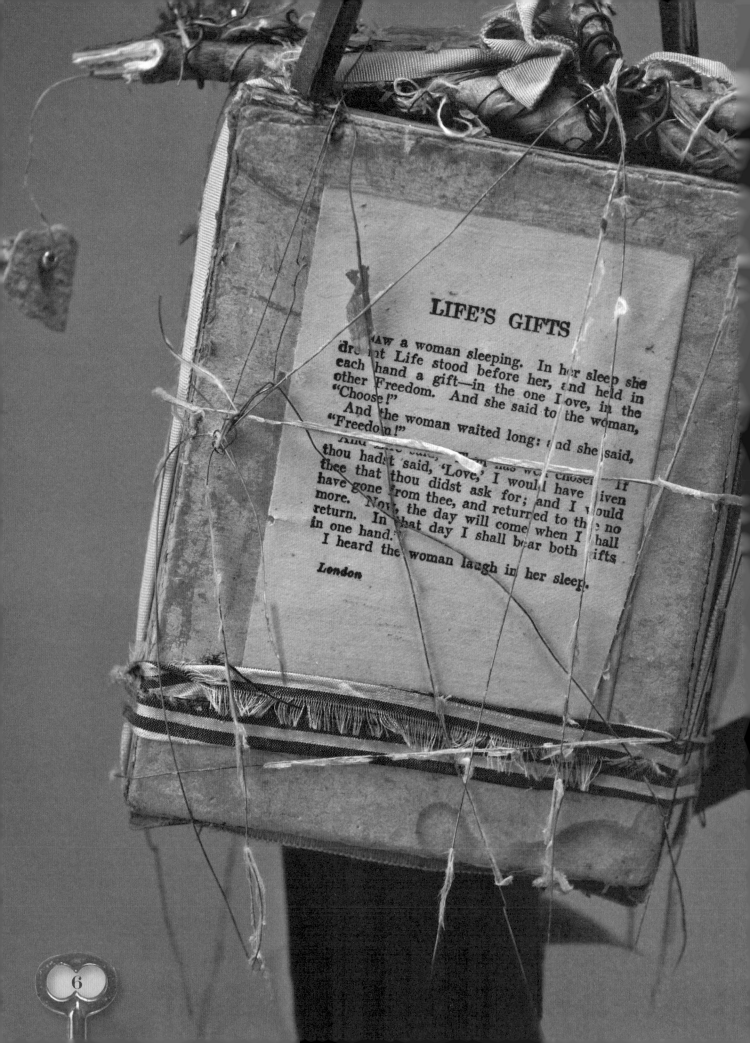

LIFE'S GIFTS

I saw a woman sleeping. In her sleep she dreamt Life stood before her, and held in each hand a gift—in the one Love, in the other Freedom. And she said to the woman, "Choose!"

And the woman waited long: and she said, "Freedom!"

And Life said, "Thou hast well chosen. If thou hadst said, 'Love,' I would have given thee that thou didst ask for; and I would have gone from thee, and returned to thee no more. Now, the day will come when I shall return. In that day I shall bear both gifts in one hand."

I heard the woman laugh in her sleep.

London

THE STILL LIFES OF LIFE

If you've picked up this book, maybe you were drawn in by the title. Maybe the idea of combining your collections and found elements resonates within you. Maybe you're intrigued or inspired by this layered, stacked, glued-and-wired look that we call assemblage.

Whatever has drawn you to this book, I'm glad you're here. This will be a safe haven, one that will give you permission to play, the capacity to seek, and an invitation into your very own free-spirited journey.

As you've taken a peek through these pages, you may have noticed that this is not your typical "how-to" book, stepping you from point A to point Z. It will, however, be a compass that will guide you along this journey, inviting inquiry and reflection to show up in your work. We will begin this journey by collecting meaningful elements as we go along—found and kept souvenirs; keepsakes and common, everyday objects that will be transformed into the uncommon; trinkets that are just waiting to find their place amongst your three-dimensional messages. I want to nudge you to create visual memories by using relics of nature along with gathered treasures. I'll also be providing some free-flowing "steps" and instruction that will help keep the creative juices flowing. Each chapter will provide "personal prompts" that will jump-start your soulful inquiry. You may literally or mentally fill in the blanks to use as prompts.

Keeping the mindless chatter at bay, this book will touch on quieting the harsh critic within, allowing us to move more freely through expression, with much less self-doubt and judgment. This all-too-familiar thief keeps creativity stuck in our souls.

In each chapter, a tagged legend will accompany the art pieces. I will share with you the messages and symbolism that are woven within each one, providing you with a key to what each object means for me. This will give you an idea of where I was going when taking the stuff of *my* heart and putting it together in this visual form. Along with these legends or maps of the pieces, there will also be space provided for you to think about some of the elements I have used and to jot down what personal meaning and symbolism these same objects might have for you—oftentimes quite different from my own, no doubt.

You will begin to notice a welcoming richness within your artwork as you share these tiny snippets of your life. When your artwork is combined and layered with the heart stuff, it will naturally begin to tell your soulful story.

The thoughts and experiences that I share here are straight from my heart. They provide little windows into my life's journey so far. I am always searching for more meaning in my artwork, and in my life. I have found that when I am willing to ask myself what is true for me, my artwork uncovers its authentic message. I have always loved to create little altars, still lifes and vignettes throughout my home and in nature. They have represented reflection and a tangible display of the stories that I have tucked away in my memories. This style of artwork encompasses this same spirit. It is my hope that you will find within these pages challenges, inspiration and insights that will offer new directions for your artwork. It's within each one of us to challenge ourselves to nourish and trust our own uniqueness. It's time to embrace your storyteller!

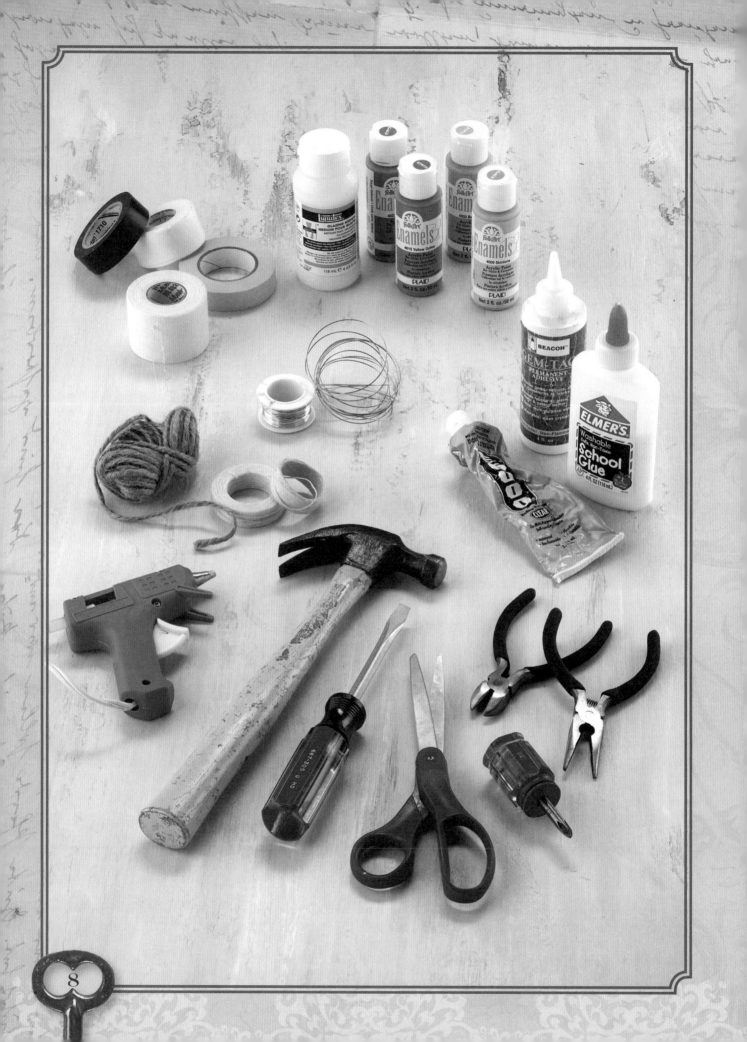

ABOUT ATTACHMENTS

If you are new to assemblage, you will soon become very aware that these suggested materials only scratch the surface of what is truly going to be an ongoing scavenger hunt! If you are a seasoned assemblage artist, then you already know that the search for the right item to attach with is almost as much fun as finding the actual "objects of reflection." Over the years, I have come to favor some materials for attaching and building over others, and you, too, will find your favorites as you work in this "anything goes" artful medium. I love it when a surprise solution surfaces when I'm not having any luck with one of the tried-and-true materials in my stash. Let's take a look at some keepers.

WIRE

The wire I like to use can range from the finer end—24-gauge—to the larger end—14-gauge—from jewelry silver, to heavy black mechanic's wire, to brass. I like to have several to choose from so I'm never at a loss as to what to use. Wiring is definitely my favorite form of attaching!

GLUES

Liquid Nails (clear), clear caulking, glue sticks, Krazy Glue gel, gel medium, school glue, E-6000—I use all of these, as each has its place at the appropriate time.

TAPES

The use of tape to hold elements down or together has its practical applications, but I really like the honest aesthetic that tape gives a piece as well. Some tapes, such as medical tape, can be aged nicely with aging medium. Common tapes for me to use: masking tape, blue painters tape, electrical tape, metal roofing tape, first-aid medical tape (the cloth kind is wonderful if you can still find it!) and floral tape.

ACRYLIC PAINT

From the inexpensive craft variety to the higher-end artist varieties, I use them all.

MODELING PASTE

I use Liquitex, but have also found that premixed spackle works in a pinch.

AGING MEDIUMS

There are many options available for instantly aging a variety of surfaces. Some of my preferred choices: Ralph Lauren Aging Glazes in Teastain, Coffee and Smoke; walnut ink; acrylic paint glazes; shoe polish/paste; Briwax furniture wax.

MISCELLANEOUS

Really, the sky's the limit when it comes to attachment options. Don't ever assume you need to limit yourself to the options I have mentioned here. Numerous other things can be used to hold or support your assemblage elements, including, but not limited to, cup hooks, screws, upholstery tacks, nails, thumb tacks, assorted chains, paper clips, ribbons, twines, waxed linen, jute, yarns and torn fabric strips.

BASIC TOOLBOX

And what about the tools you might need to assist with the actual attaching? Here is a simple list of what you will probably want to keep withing reach as you work:

Clamps

Wire cutters

Screwdrivers—assorted styles and sizes

Awl (or a big nail)

Hammer (a small one is fine)

Jewelry pliers—assorted sizes

Tweezers

Scissors

Sandpaper—assorted grits

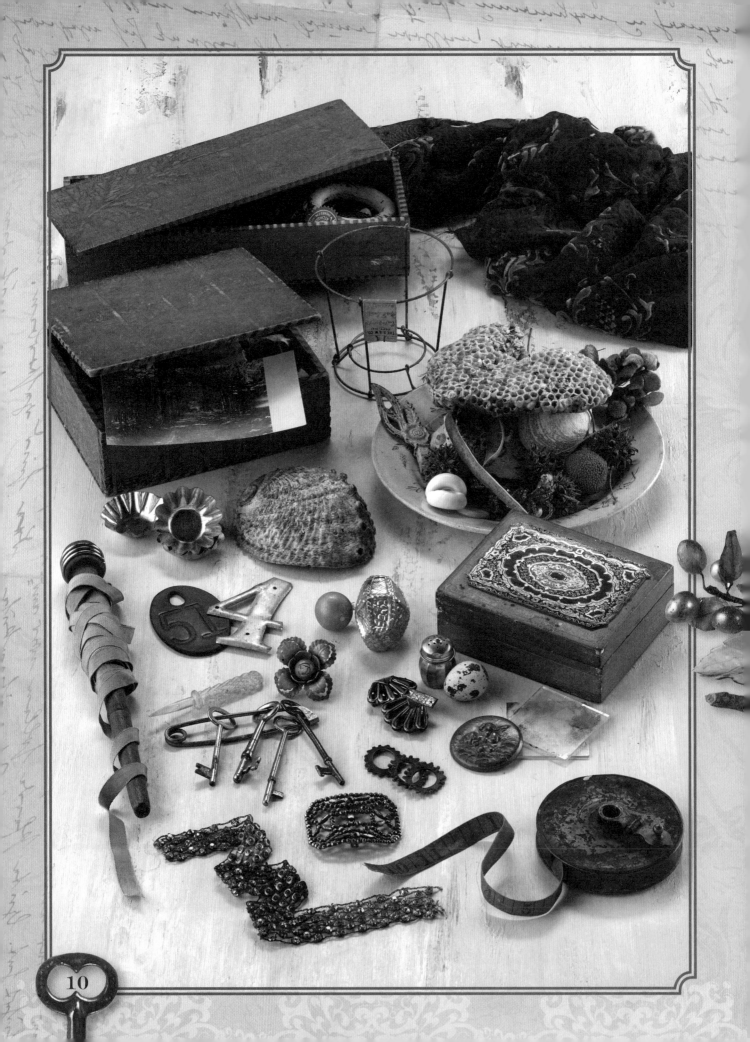

OBJECTS & SUCH

This book is full of unique ways to tell your stories and to share your memories. In each chapter, I have added, along with the photos of the artwork, what I was thinking as I created each piece. I tried to share how the objects were interpreted by me, but that by no means implies that you should have the very same feelings about the same items.

I thought I'd offer up some ideas here about what you might be able to use for what I like to call the "bones" of a piece, but *bases* or *core foundations* sounds a little more official! A core foundation usually serves as the largest object in your assemblage but not necessarily the focal point. It's what all the other items are built upon, or housed in. When I begin a new piece, this is usually the jumping-off place, but not always! Sometimes one teeny tiny find will be the start of an entire piece. I try not to dictate how I begin a new assemblage; I just try to let it lead me where it wants to go. Patience is a necessary virtue when searching for just the right elements to complete your work.

Look over the "bones" list below, and see if it sends you spinning off into other possibilities. Jot down what flows into your thoughts for future reference. As you can see, the list is limited only by your own imagination! Some of these can double as freestanding sculptures or ones that could hang like a mobile. It really depends on your vision.

Where do I find these goods? Everywhere! But my favorites are flea markets and garage sales—better known in some parts as yard, tag, porch or estate sales. I remember the very first garage sale I ever went to! I think I was six or seven years old, and my next-door neighbor, Mr. Carey, was my very first dealer! I bought my momma a white porcelain fluted vase with tiny pink roses on it. I remember thinking, "He's selling this for how much? I'll take it!" From there on out I was hooked. Then I discovered thrift stores in my teens, and, as they say, the rest is history! If I'm on the road, before finding a place to stay or eat, I seriously scope out the Salvation Army and the Goodwill stores, or even better—the little local church-run thrift stores in town! They are chock-full of great donated items. When I had my funky little antiques shop, Mabel Annie's, I loved it when dealers would pull up to my shop, open the back of their trucks and let me shop 'til my little heart dropped. Now that's what I call a "tailgate" party!

As you make your way through the book, take notice of the legends that accompany the artworks. Make notes as to where some of these items may lead you as you search for your forgotten finds. Don't overlook the obvious; your own keepsakes, jewelry and treasured tokens are always the best places to begin.

antique tins	architectural element
cigar boxes	drawer
old wooden hangers	old bottles
metal lunch boxes	boot or skate
child's toy	tree branches
jewelry box	driftwood
vintage book/ledger	antique purse
chippy frame	hand mirror
old boards	curtain rods
lamp parts	game boards
lamp shades	basket
cake pedestal	recipe box

SYMBOLIC STORIES

The creative is the place where no one else has ever been. You have to leave the city of your comfort and go into the wilderness of your intuition. What you'll discover will be wonderful. What you'll discover is yourself.
—Alan Alda

DIGGING DEEP

Whether you are brand-spanking-new to assemblage or you've been at it for a while, it's my hope that something within these pages will be an inspiration for you to experiment with the possible notion of telling your story, along with digging into your memories or the shared memories of a loved one. I'd like to encourage you take off your blinders and see the whole spectrum of possibilities for your newfound words. We all are aware of what coloring inside the lines feels like—too restrictive and very predictable. This is what we don't want to carry over into our art.

Take a good look around your world. Keep your eyes peeled for your new three-dimensional, symbolic "words." From here on out, give yourself gentle reminders to not set any boundaries on the ingredients you think you can or should use in your work. Here in this process we will be using relics of nature along with hoarded bits and pieces of junk scattered upon our tables and hidden in the nooks and crannies of our ever-so-humble studios. We will be exposing these items as symbols and metaphors—ones that will represent a specific memory or story.

Don't forget to look inside those closed dresser drawers or the boxes at the top of your closet, and see what you've cherished and collected. It could be a note, a tiny love token or maybe a childhood kitschy item. These treasures will be words for your artwork.

Do you see and feel the connections to these collections that dot your world? Begin here. Begin with what speaks to you. Begin to tell your story through soulful inquiry and reflection. From this humble start, let your mind wander in and out of this concept. Soon you will be able to recognize intuitively what should go hand in hand when approaching your work, to give it real meaning.

The artwork you will see here in this book are pieces that I have in my home, from where they will probably never leave. They are that personal. This style of assemblage is a chronicling of history, of treasured moments, of remembrances.

This art form is not about talent. It's about the artist's passionate inner stirrings and visions of what needs to be expressed in his or her outer world. I'm sure you've experienced walking into a gallery, a street sale, a museum or a friend's home, and seeing a piece of art that actually made you feel the power of what the artist is communicating (or in other cases, sadly not!). Of course there will always be tricks of the trade that will help you to flow through your artwork, whatever the medium may be, but when it's all said and done, it's about being able to express yourself with your own creative voice. There is no right or wrong way. It's all about getting the juicy stuff out of our heads and hearts and onto the page, or in this case, out and into this form of freestyle sculpture.

And, although I will ease you through some tried-and-true techniques that I've found to be easy shortcuts to keep the creative juices flowing, as I mentioned in the introduction, this book is not going to step you through each and every art piece as if you were going to recreate it; instead, it will open your eyes to new possibilities. Along the way, you will find your rhythm . . . your style, your voice will emerge. All you have to do is show up and be willing to listen and foster trust.

Allowing the process to unfold is not instantaneous each and every time—but, there will be times when the ideas will swell within you so much that you will know that a deeper creative awakening has occurred. Keep a pen and paper handy—especially by your bedside. Dreams and ideas run rampant when we shut down our critical-thinking left brain! Capturing and honoring what flows to you is essential in any kind of creative form. Let it spill out as raw passion. There is no time for cookie-cutter art here. This is a time to embark on the juicy stuff: the bits and pieces that have made a home in your memories.

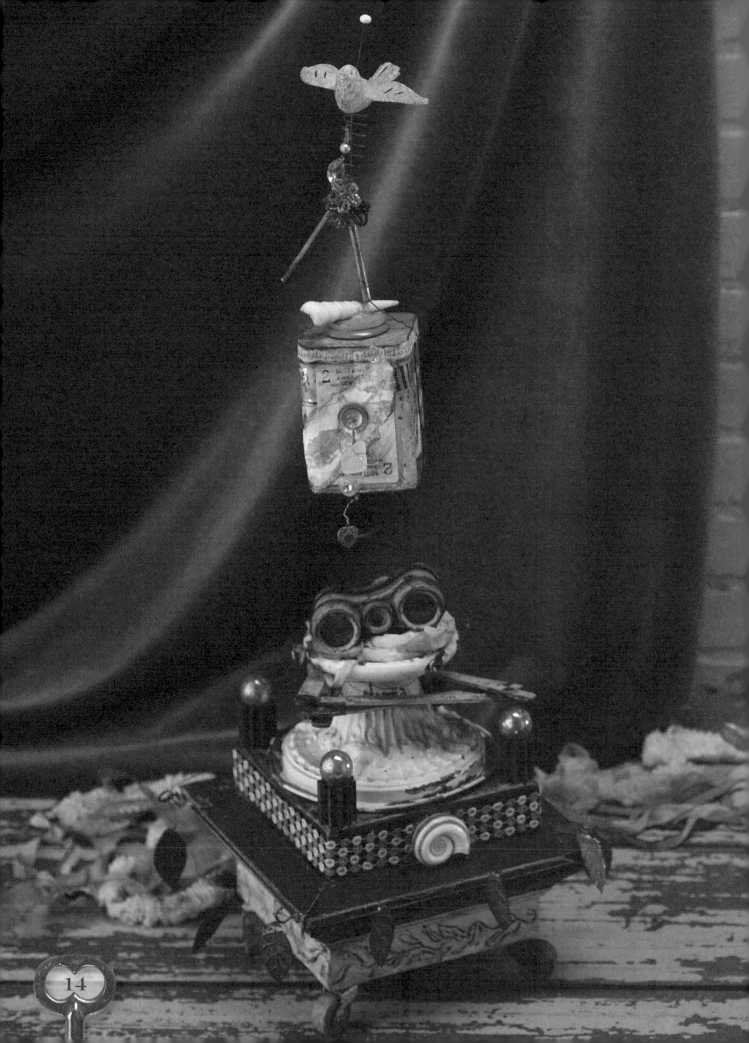

14

TIDES OF CHANGE

tides are dancing
along the shores
of my heart.
seeking out the
joyful sightings
along the waves
of promises
rolling in like
ribbon candy
made of light.
tossing my net into
the ocean catching
then releasing the
trusted lessons that
bring me to the true
blue shore of my soul.

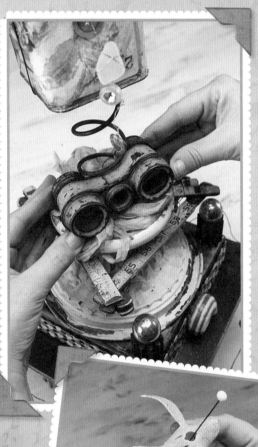

I began this piece using an antique column post top as the base and attaching old wooden rollers to the bottom. Here I drilled holes, then to secure the casters inside, I added some liquid nails. This was one of the first assemblages I did that was relatively large—at least it seemed large compared to what I had done previously. I played around with what and how I would send this one soaring, and I believe this was the first time I used a rusty bedspring in my work. (I coat these with a clear matte sealer once I clean them off a little.) Attaching the spring to this wonderful embossed and aged light fixture was a snap: I just used the holes and screws that were already there on the metal rim and screwed the spring onto it. It was surprisingly secure.

I then began to work on collaging the buttery-colored tin with vintage papers, a mother-of-pearl button, shells, wire and aged tea-stained fabric—all adhered with a clear acrylic gel medium. The tin was then attached by wrapping wire around and through the top of the bedspring and then bringing it up to a point and twisting it so it would fit snuggly inside the bottom of the compass—again, another perfect fit. An extra-long hatpin held the bird, spring and beaded flowers in place, inserted down through a hole in the top of the compass.

I'd like to say here that not all of this fell into place in one fell swoop. The perfect elements evolved over time. Patience is essential to getting a piece to flow into the story that you've envisioned. This is what happened here for me with this one, and really, this will most likely be the case with most of your work, especially since each element represents a vital message within the artwork as a whole.

TIDES OF CHANGE

So, when I came across some great aqua-green opera glasses, they became an amazing outlet for my story, as did the folding ruler and the bird. On the four corners of the post topper, I glued these great fluted gears that I dug out of an old box at my all-time favorite junk store. I added some textures with the gold and cream trim that was glued at a few intervals. The modeling paste was troweled on and then carved into and painted with acrylics, and tea-stained interfacing was scrunched beneath the binoculars. The metal leaf garland is new and was attached with old cup hooks that were screwed into the corners of the post and then loosely draped around the outer edges.

All of these things were chosen for four different reasons: first, what they "said" to me; second, how they added a different layer or dimension to the artwork; third, for color; and fourth, for repetition.

You will know when too much is too much for what works in your art—gilding the lily, so to speak. It will just feel complete.

This is probably a good time to mention that I have some work that still doesn't feel complete, but when I find that perfect find when I'm out scouting around, I cannot wait to get it home and put it where it belongs. Because life is constantly changing, I have some still lifes or altars in my home that I'm constantly adding to and taking from that are part of my ongoing story. I love these reminders of life happening and changing.

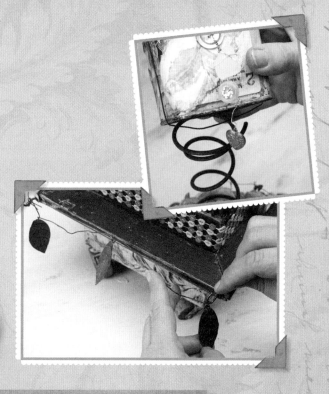

BIG THOUGHTS, BIG DREAMS

Don't limit yourself by working small. If you come across a larger item, don't dismiss it. Working larger has a freeing feeling about it. It oftentimes will serve as the perfect "bones" of a piece. Let intimidation take the day off.

PERSONAL PROMPTS

I HAVE THE CAPACITY TO

I LET GO OF

I YEARN FOR

LEGEND

1. Bird—explore
2. Prism—reflecting the light
3. Tin box—memories
4. Brass heart—love
5. Rusty bedspring—springboard
6. Binoculars—vision
7. Wooden ruler—years
8. Aqua ornaments—sky
9. Four gears—keep moving
10. Spiral shell—washed ashore
11. Brass leaves—growth
12. Wooden wheels—travel

Consider each of the objects here, and jot down your thoughts about what each might represent to you.

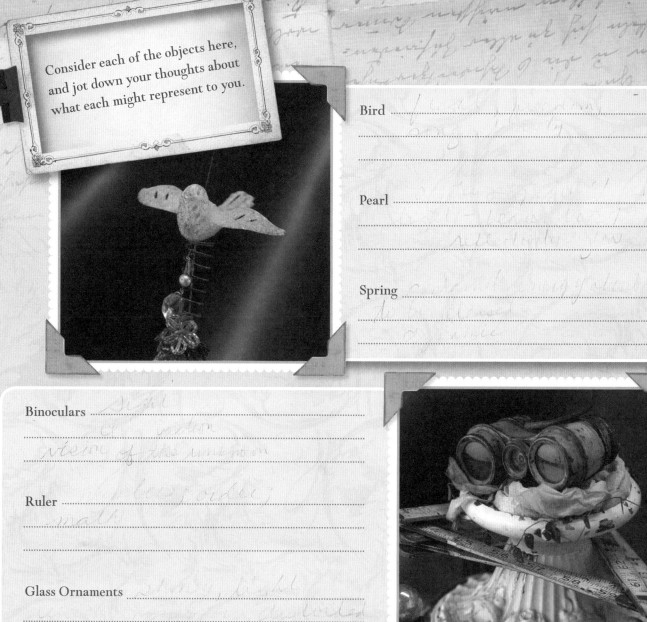

Bird _____

Pearl _____

Spring _____

Binoculars _____

Ruler _____

Glass Ornaments _____

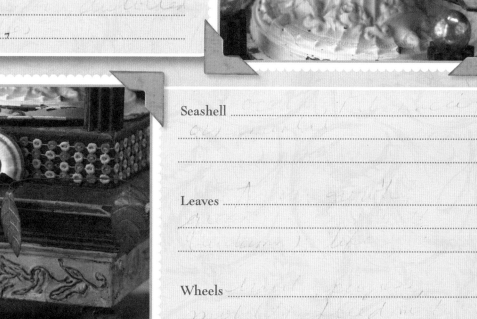

Seashell _____

Leaves _____

Wheels _____

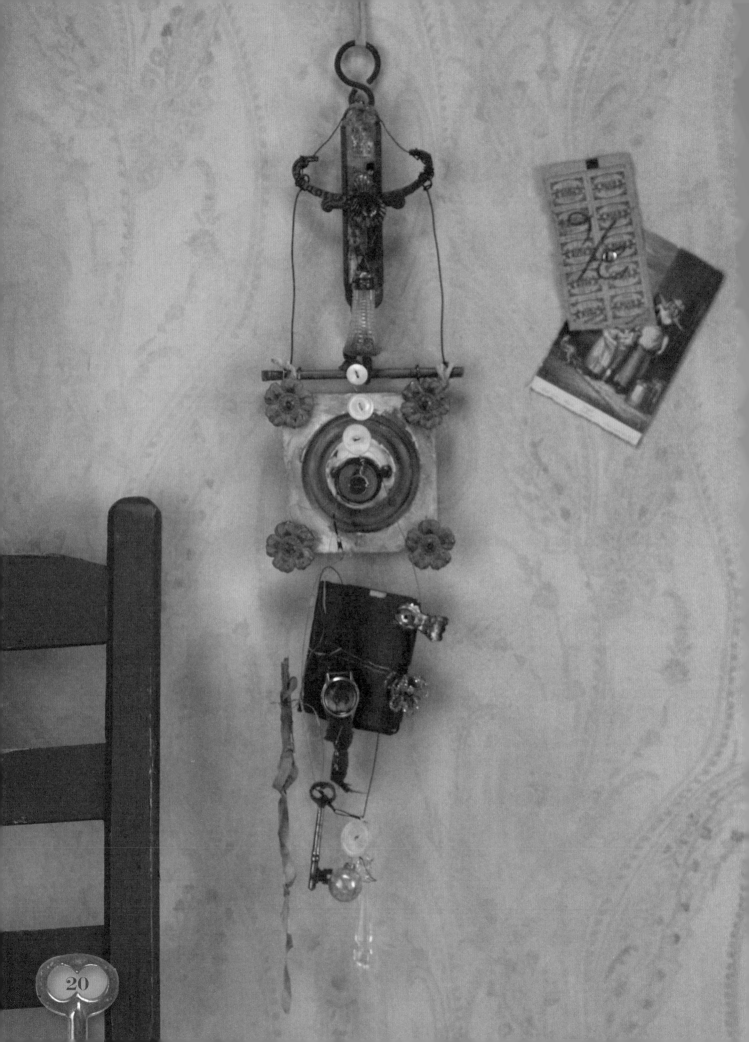

UNWINDING DREAMS

There are days

that the clouds speak

to me in whispering

dream wishes

Wishes unwinding in

the quiet spaces

In the catches of the day

timeless sightings are waiting

in the water and sky

Reflections of the magic

sea wash over me

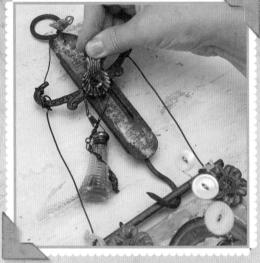

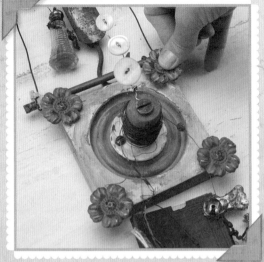

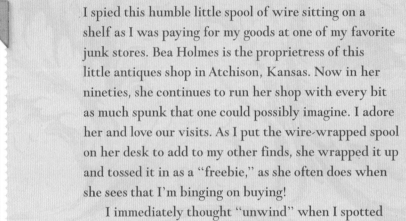

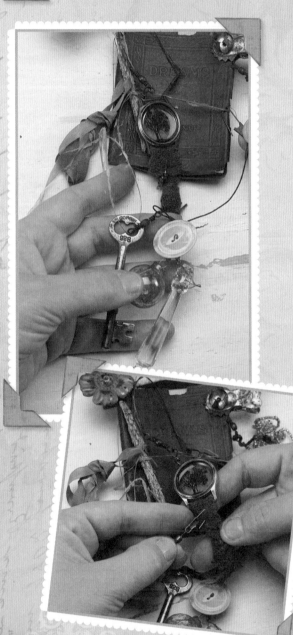

I spied this humble little spool of wire sitting on a shelf as I was paying for my goods at one of my favorite junk stores. Bea Holmes is the proprietress of this little antiques shop in Atchison, Kansas. Now in her nineties, she continues to run her shop with every bit as much spunk that one could possibly imagine. I adore her and love our visits. As I put the wire-wrapped spool on her desk to add to my other finds, she wrapped it up and tossed it in as a "freebie," as she often does when she sees that I'm binging on buying!

I immediately thought "unwind" when I spotted this treasure. Then, my mind raced all the way home on what other moments help me to unwind; hence, the old watch face with a photograph of a tree placed within her golden circle—much nicer than time staring you in the face. And the added fishing elements remind me of times spent with my "foxy" grandpa, back in the day—another calming memory. (Yes, that's what we called him, and his daddy was Great Foxy Grandpa! Never knew why, but it suited him just fine!)

This one little spool of wire is where I began with this piece, and, strange how my mind worked, I also envisioned it on the wooden trim square, making no mistake that it would be the center of attention. I screwed these two pieces together, then set them aside for the time being. Once I gathered the fishing gear and laid it out, I knew I would make this into a hanging "off the wall" piece.

A tiny *Dreams* book was one of many in a set that I took down off my shelf. I didn't want to alter the book in any way, so I lightly wrapped a very tiny wire around it so it would just lie nicely within. I did this for a couple of reasons: one, to not devalue the book;

UNWINDING DREAMS

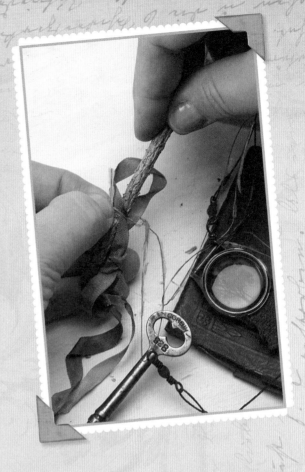

and two, so I could read it again! The watch with no face quickly got a "face lift" by adding an image of a tree, then filling it with resin. The four floral metal curtain elements were a last-minute find. I trusted that when I found what I was looking for, I'd just know it. The color and textures of these were perfect—no altering required.

As I mentioned before, I will do without something on a piece until the right thing comes along. This is why some things stay in a lingering state for a while. The fish scale was another last-minute find; again, the texture, size and color were a perfect fit. Tiny additions like the key (open heart), the crystal saltshaker (salt of the earth) and the faded ribbon (flowing as a kite) all tie in nicely with sentiments that were dancing around in my head at the time.

NOW AND THEN

Don't be afraid to mix new and old elements together. Here, just adding modeling paste (see page 9) to the brand-new wood square and then aging it with paint and stain was all I had to do to get it in the right decade.

PERSONAL PROMPTS

When I show up, I

Today I will allow myself to soak in

I am willing to release

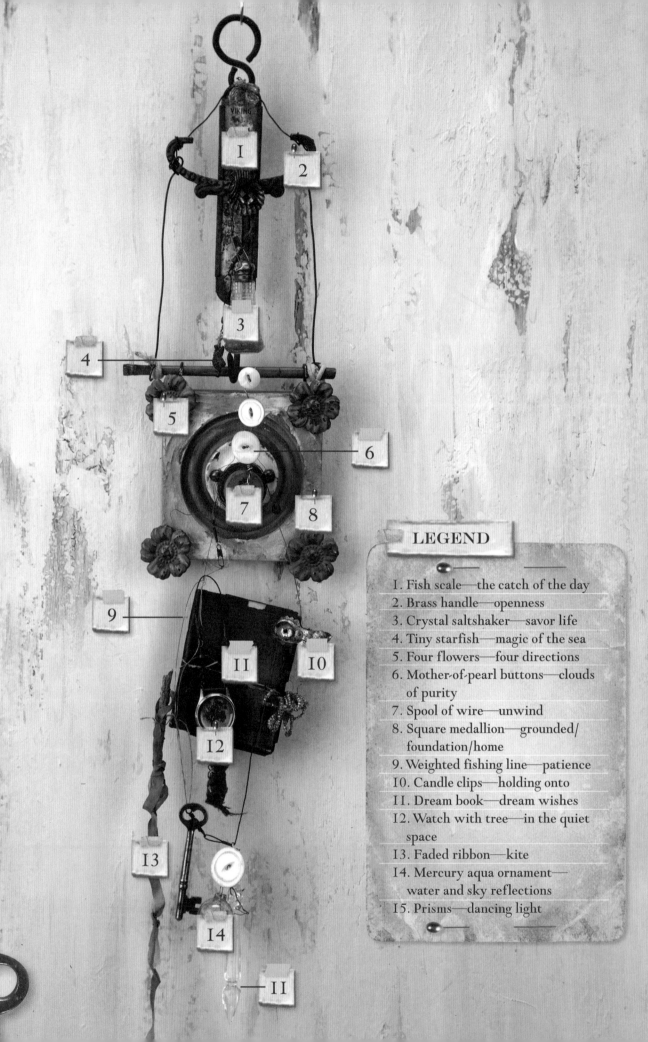

LEGEND

1. Fish scale—the catch of the day
2. Brass handle—openness
3. Crystal saltshaker—savor life
4. Tiny starfish—magic of the sea
5. Four flowers—four directions
6. Mother-of-pearl buttons—clouds of purity
7. Spool of wire—unwind
8. Square medallion—grounded/ foundation/home
9. Weighted fishing line—patience
10. Candle clips—holding onto
11. Dream book—dream wishes
12. Watch with tree—in the quiet space
13. Faded ribbon—kite
14. Mercury aqua ornament— water and sky reflections
15. Prisms—dancing light

24

Consider each of the objects here, and jot down your thoughts about what each might represent to you.

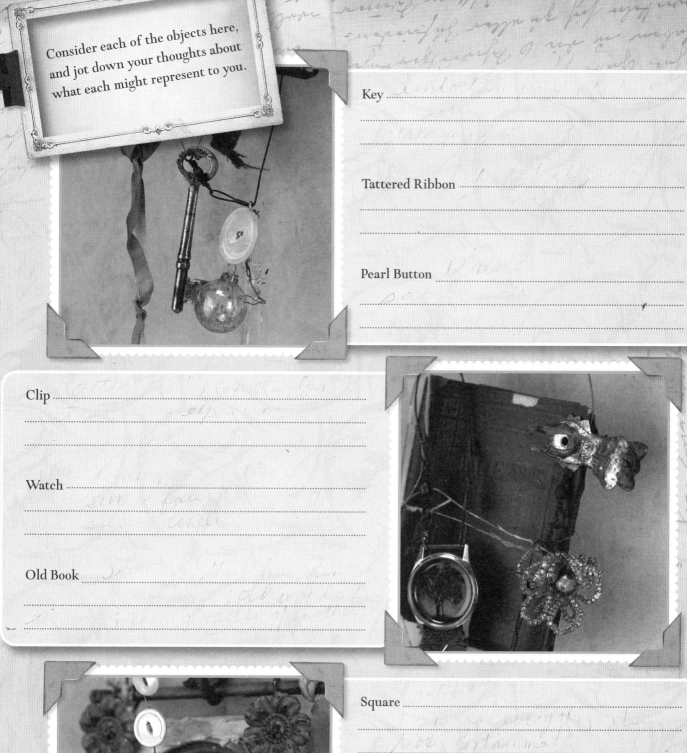

Key ...

Tattered Ribbon

Pearl Button ...

Clip ...

Watch ...

Old Book ...

Square ..

Spool ...

Flower ..

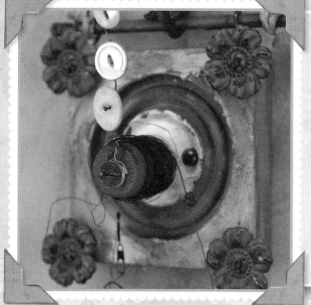

SEEKING INSIGHT

Be yourself; everyone else is already taken.

—Oscar Wilde

INTENTION AND BEING FEARLESS

I am one who loves to dream. I've wished and dreamed upon the stars ever since I can remember.

Star light, star bright,
first star I see tonight;
I wish I may, I wish I might,
have the wish I wish tonight.

This childhood poem was taught to me and my two sisters at very early ages, and each evening when I saw my very first star, I'd make a wish. I believed with all my heart that my wishes were going to come true—hook, line and sinker, no doubt about it! Wishing is magical, and dreams are the heart stuff, and I will never stop believing in either one. With that said, I am now a woman who knows wishing and dreaming have to be backed up with intention.

Having a clear intent of the world you are dreaming of or wishing for is what makes those dreams happen, otherwise they could stay in a dreamy state forever. So, for the purposes of this book, and its focus for you, I openly invite intention to move in, unpack her bags and get real comfy-cozy in your creative soul for the duration. For this is where our wishes and dreams of living a creative life turn the heart stuff into reality.

INTUITION: THE INNER MESSENGER

Intuition fits nicely in the creative world as well as in the big picture of your life. It helps us to know when something is working and when it lies hidden. I believe intuition bubbles up from a special place within the heart, an inner knowing—the sixth sense. I like to envision intuition as the messenger from the heart. It's all a matter of being willing to listen to those creative ramblings that resonate and reside in us.

When we do listen to these heart stirrings, our work can't help but reflect these stories and intuitive insights that we had hoped would unfold. Asking what sparks our creativity and waiting for the answer,

as we begin a journey into our creative center, has a connection to our personal musings and not just a random theme. These promptings nudge us to delve into the intent of a piece—so personal that it resembles, without words, a page from our journal. What comes from the heart is so universally powerful. A cherished letter, a special encounter or person, a childhood memory, a treasured find, or a kind word—all have such a powerful energy when infused into your artwork. It's the heartfelt stuff.

INSPIRATION: DELICIOUS CLARITY

Inspiration comes from a similar place as intuition, and though they are closely related in our inner world, especially with memories and feelings, they are different. Inspiration is all around us and fills our senses with an earthy overload of our surroundings: color, music, people, textures, sounds, smells, tastes.

What draws you in? What gets to you and makes your little heart pitter-patter? Pack your journal and carry it everywhere you go. Take the time to jot down words or notes that help you to remember what you witnessed and emotions that filled your day. It's a rare occasion that I don't have my camera with me for this very reason. A camera really helps jog your memory at the end of the day when you want to document and remember all the details about treasured thoughts and who crossed your path.

Make a conscious effort to live whole-heartedly—your dreams front and center—with intent serving as the portal. We all are on a similar path, I believe, one that teaches us our lessons if we are open to what and who is presented to us on any given day. I know that I need these reminders in my world.

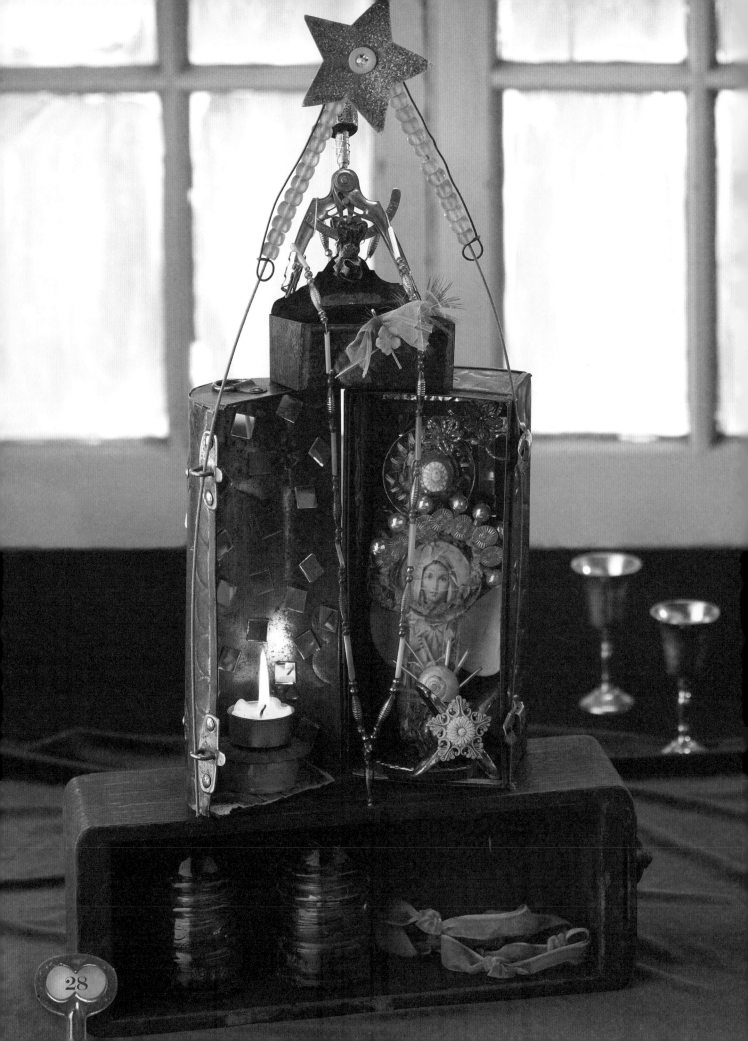

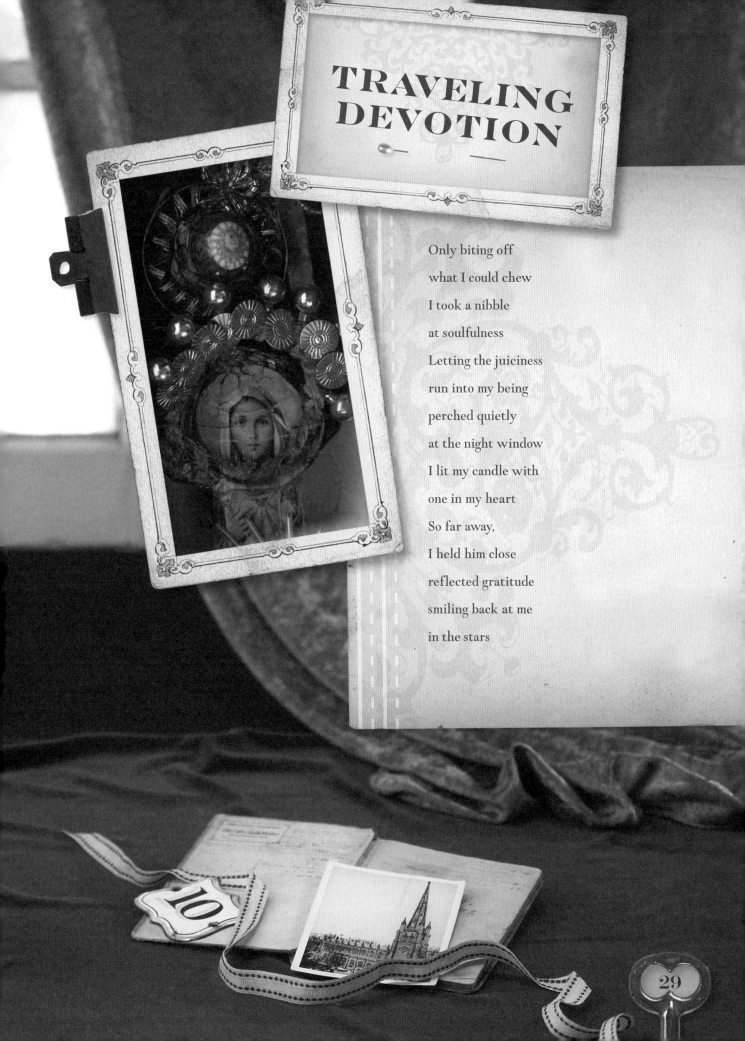

TRAVELING DEVOTION

Only biting off
what I could chew
I took a nibble
at soulfulness
Letting the juiciness
run into my being
perched quietly
at the night window
I lit my candle with
one in my heart
So far away,
I held him close
reflected gratitude
smiling back at me
in the stars

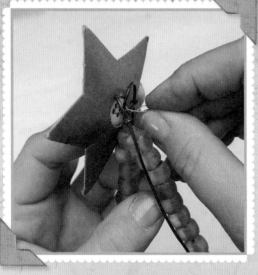

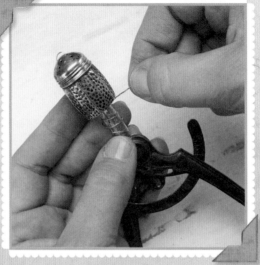

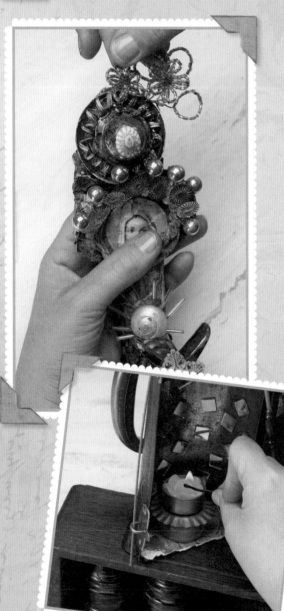

When on the road, I like to take a candle with me. It always makes home seem not so far away, and there is always someone or something that I like to hold in the light. So, the concept of a small altar to travel with really appealed to me, and using a vintage Mexican theme appealed to me even more. I actually made part of this during a class at an artist retreat, and it sat as the center of my little altar in my studio for a couple of years until this notion took hold of me.

I have a few of these wonderful, very functional old tin lunch boxes that I've stashed many collections in over the years, or have used to house some art materials when on the go. To find that my small, funky altar fit perfectly within one side of this stamped lunch box was all it took for this piece to take on a life of its own. With the lunch-box addition I loved the idea of "Soul Food" as a title, but a friend suggested "Traveling Devotion," and I agreed that that really captures its truest meaning.

This piece was created in a class I took, for which I had brought only a small stash of items from home to use to create it. One item was a Mary bookmark. It was new-looking, so I crumpled it up and glazed it with a very faint Raw Umber–ish wash to make her appear to have been ages old. The hot faucet was in the teacher's junk pile, and since I knew it would be a challenge to work with, I took it. It turned out to be the perfect base and added a "use-what-you-have" appeal I adore.

The pearlescent spiral shell with her mercury slender beams and the celluloid star shell were just enough to carry out this vintage sailer art story without becoming too theme-ish. Tiny square mirrors

TRAVELING DEVOTION

At first glance, this seems a bit elaborate to tuck into a suitcase, but the outer pieces are removable and fit sweetly into a drawstring bag, and they are easily put into place once you want to set up your altar. If she isn't traveling around with me, I set her on top of an old oak sewing cabinet drawer with vintage glass insulators. These seem to anchor the entire altar and give it a bit more prominence, not to mention they add to the meaning behind the elements.

haphazardly placed inside the domed side make the perfect reflecting "pool" for the candlelight.

A roof of aqua glass beads frame the small tin box that sits atop this altar. It is here that I place my thoughts, words or prompts that I choose at random for inspiration.

I topped her with a mica reflector star and a tiny sterling saltshaker, and I draped a vintage mercury garland over her that reminded me of a delicate rosary of sorts—protection of prayers.

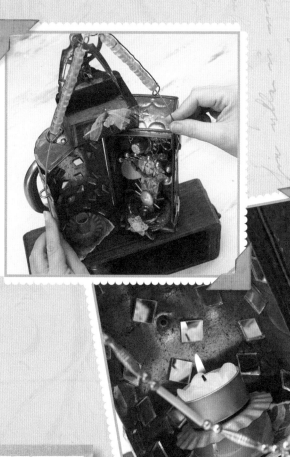

SAFELY SEALED

When using vintage metal or tin elements, it's good to give them a thorough cleaning with a mild soapy wash, dry completely, and then give them a good shot of a thin spray of matte (my preference) sealer to keep them "preserved" a little longer, especially if they come along with rusty spots.

PERSONAL PROMPTS

WHAT IS IT THAT I TRULY WANT TO CONVEY WITH MY ARTWORK?

HOW CAN I BE TRUE TO MY VISION AND STORIES?

HOW CAN I LET MY AUTHENTIC VOICE SHINE?

LEGEND

1. Star mica—wishes
2. Sterling saltshaker—season of life
3. Green floral wire—home
4. Tiny paper flower—sweetness
5. Small rusted box holding "thoughts"—devotions
6. Mirrors—reflection
7. Shells—miracles
8. Mercury bead necklace—prayer
9. Tiny aqua mercury ball ornaments—sky
10. Mercury silver cylinder beads—rays of hope
11. Spiral shell—introspection
12. Candle—light the way
13. Celluloid star pin—my five children
14. Old faucet—let it flow
15. Knotted velvet ribbon—hold on

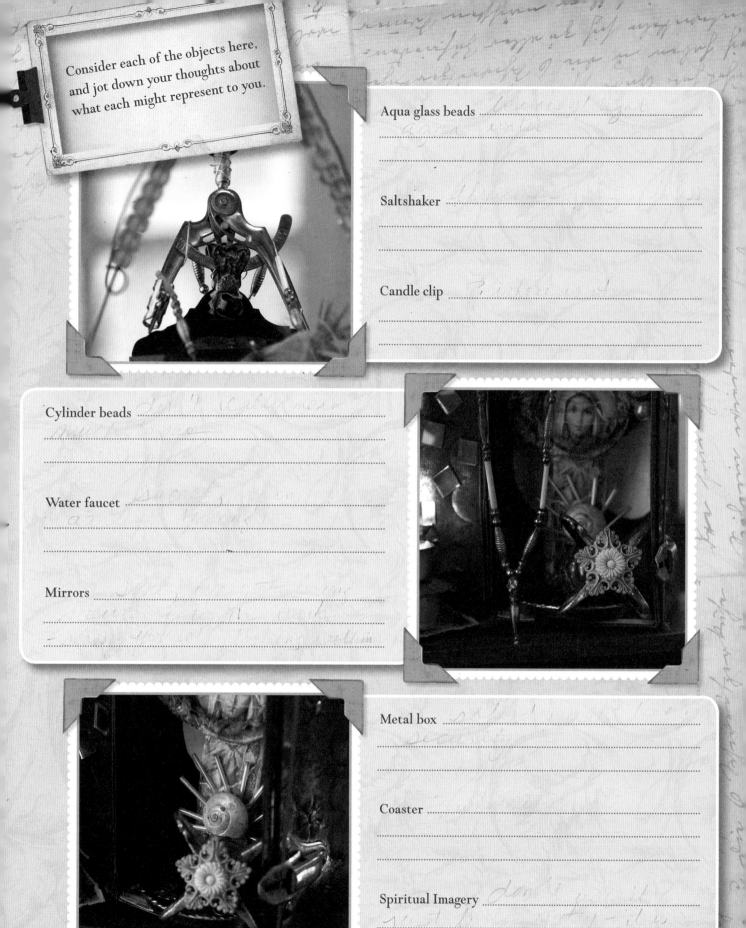

Consider each of the objects here, and jot down your thoughts about what each might represent to you.

Aqua glass beads *[handwritten notes]*

Saltshaker *[handwritten notes]*

Candle clip *[handwritten notes]*

Cylinder beads *[handwritten notes]*

Water faucet *[handwritten notes]*

Mirrors *[handwritten notes]*

Metal box *[handwritten notes]* security

Coaster *[handwritten notes]*

Spiritual Imagery *[handwritten notes]*

33

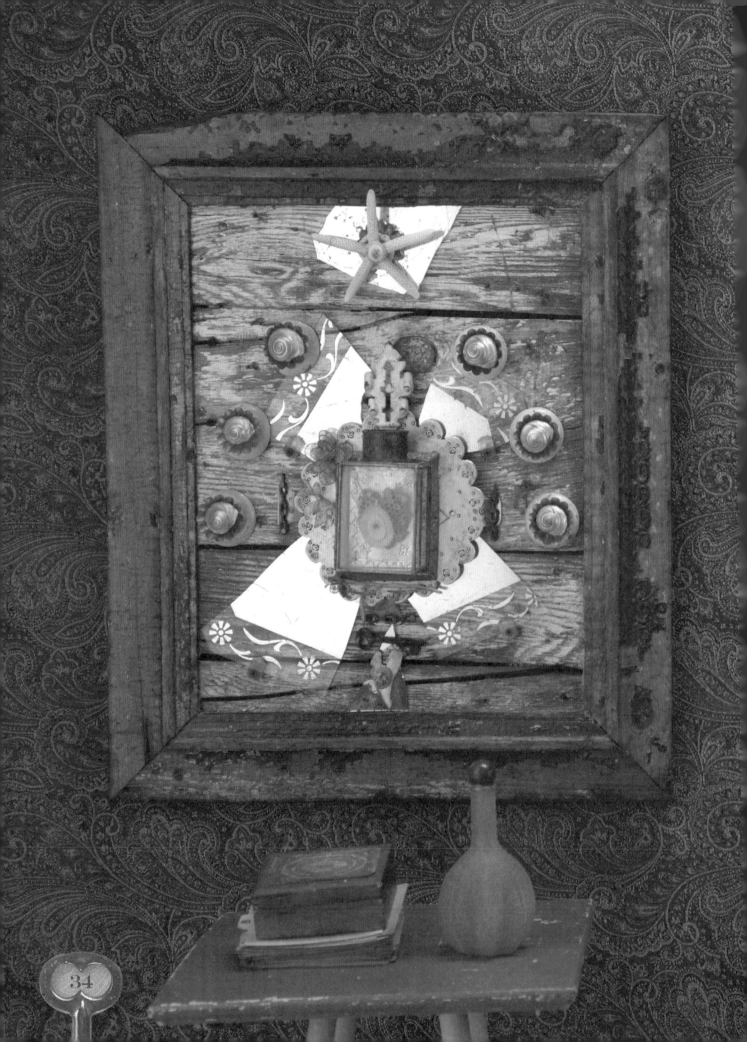

THE SACRED HEART

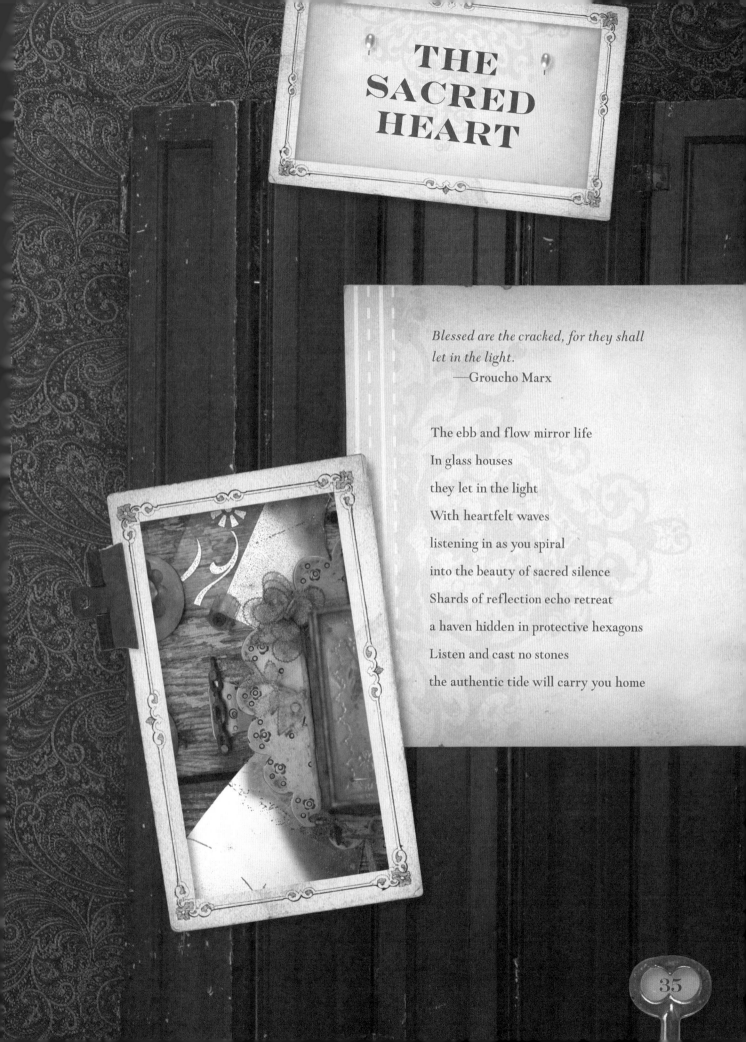

Blessed are the cracked, for they shall let in the light.
—Groucho Marx

The ebb and flow mirror life

In glass houses

they let in the light

With heartfelt waves

listening in as you spiral

into the beauty of sacred silence

Shards of reflection echo retreat

a haven hidden in protective hexagons

Listen and cast no stones

the authentic tide will carry you home

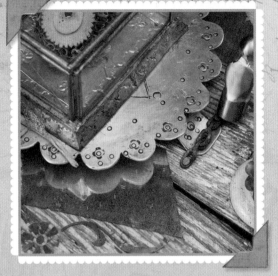

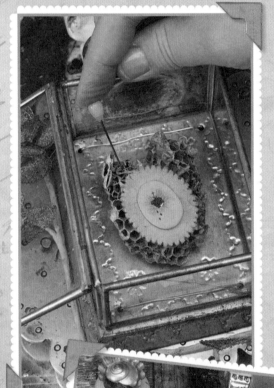

This little tin-stamped glass trinket box, a vintage souvenir from Mexico, had long since lost her allure for the previous owner and found herself sitting smack dab in the middle of a dusty shelf in a Colorado thrift store named Defiance, which made me laugh, thinking of its definition: "To challenge the power of; resist boldly or openly: to defy parental authority."

This sounded very familiar! There on the shelf she waited patiently, to find her second life—and that, she did. Defiance was good to me that day, pouring out other finds that were going to help jump-start this "still life" story—mind you, a story that had not even begun to be written at the time but was just a tiny vision in my mind's eye. Oh, the possibilities!

I just knew when my dear friend—one that I have been friends with since kindergarten, another Annie (better known as T.O.A., or, the "other" Annie, which is how I'm referred to when I'm on her turf!)—showed me this amazing little see-through "home" with the crack in it, I was hooked. In fact, the crack was an asset! Immediately, my wheels started turning, thinking of working titles, like "Throwing Stones" and "Living in Glass Houses," neither of which stuck. So, I had to have it, along with the dirty little scalloped trivet that she held up with a questioning "This, too?" Yes ma'am! Gotta have that one, as well. I turned around and the tiny tartlets were staring me in the face. I took all of them.

It felt like Christmas to me as I left Defiance that day. So, these little memory makers that were collected along the way—from that trip in Colorado to the trip I took a few weeks later while visiting another dear lifelong friend (more about her in another chapter!)

SACRED HEART

in the Phoenix area—landed me with a trove of treasures. All of these finds not only make this piece meaningful for me, but will forever stay with me as a reminder of the summer of '08 spent with these two amazing friends of mine. And now, here they all are, most left in as-found condition, just like I like 'em.

From the very beginning, I had a vision of a vintage Mexican shrine, one that had evolved over time acquiring the perfect peely and chippy paint, along with hand-carved, aged tin. Beginning with the small glass trinket box that was "made in Mexico" as the focal point for this piece and anchoring it with a more substantial base (an aged aluminum trivet) underneath, gave the box more of a prominent position on the large frame. The actual frame was one that I had refused to toss on so many occasions over the years,

having a love of the intricate design that sprinkled it. It had to be glued and secured with braces on the back, and I used a clear acrylic matte medium to glue down and seal the wood with what was still salvageable of the plaster-work design.

The wide planks with original white paint that make up the backing for the artwork came from an actual old barn door. Within the glass "house" I knew I wanted a nest and was happily surprised by one of my wasp nests that fit perfectly inside. The little felt charm, with a sacred heart on it, sits proudly on top of the nest. I never flip-flopped with this decision. It felt right from the very get-go, so there it stayed.

Since I had no pre-conceived idea as to what the heart meant, I now have my own personal interpretation. (I honor and respect the original meaning it has for thousands of people throughout our universe.) To hug the outskirts of the "home," I chose to use some tiny tin tartlets as a border to take the eye toward the top of the piece, where the "star" shines above. My love of the ocean is always manifested in my work somewhere, as is the five-pointed star—in this case both—a starfish.

FRAME OF MIND

Whenever you are working within the boundaries of an actual frame (there really are no boundaries, as we all know!), lay the frame down on a flat surface and begin to map out your design, then begin building/designing from the inside out. If you choose to take the elements beyond the frame's boundaries, this makes it easier to visualize the scale of the piece.

PERSONAL PROMPTS

WHEN I AM OPEN TO MY CREATIVE GUIDANCE I

WHEN I CARVE OUT CREATIVE TIME IN MY DAY I

WHEN I SEEK A CREATIVE RHYTHM, MY LIFE FEELS

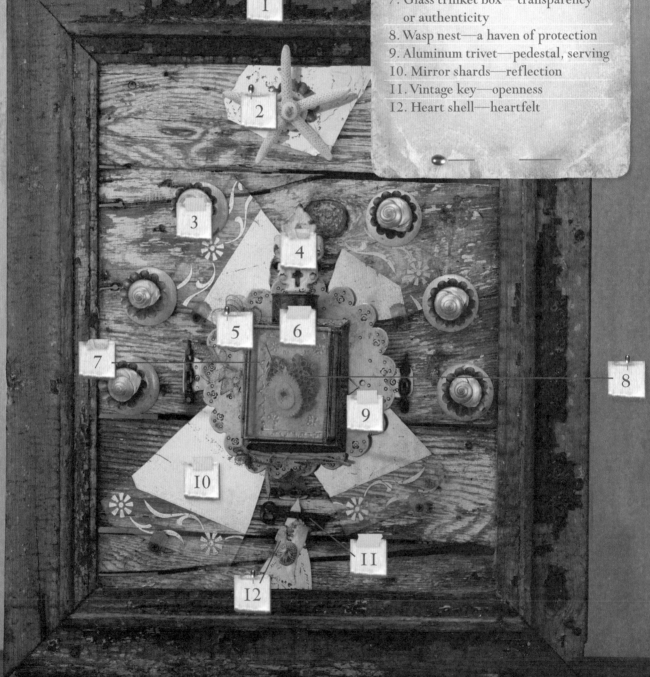

1. Old crusty frame—still useful
2. Starfish—five children
3. Spiral seashells—introspection
4. Iron finial—adornment
5. Gold & silver beaded flowers—
 beauty in nature
6. Sterling napkin ring—crown
7. Glass trinket box—transparency
 or authenticity
8. Wasp nest—a haven of protection
9. Aluminum trivet—pedestal, serving
10. Mirror shards—reflection
11. Vintage key—openness
12. Heart shell—heartfelt

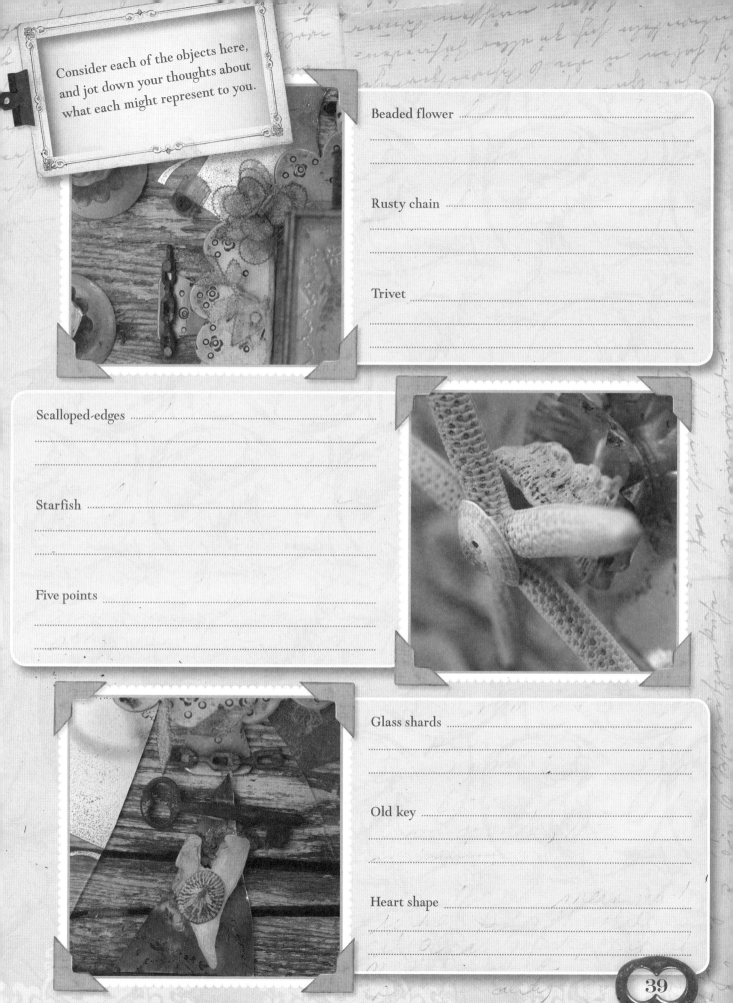

Consider each of the objects here, and jot down your thoughts about what each might represent to you.

Beaded flower ..

Rusty chain ..

Trivet ..

Scalloped edges ..

Starfish ..

Five points ..

Glass shards ..

Old key ..

Heart shape ..

39

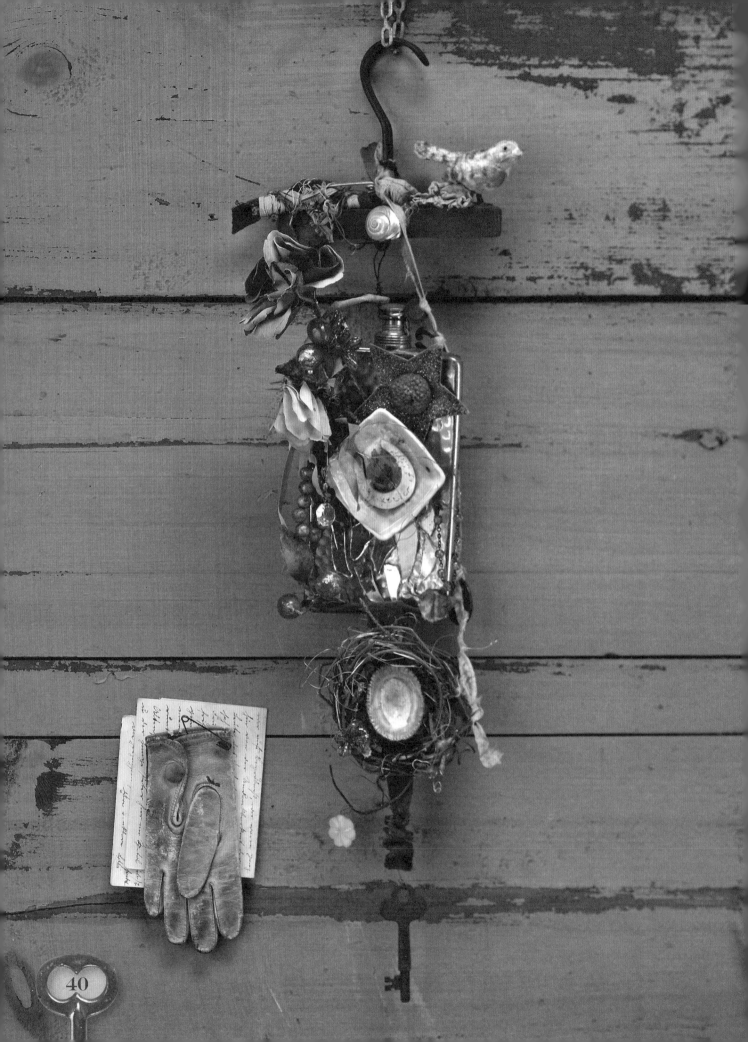

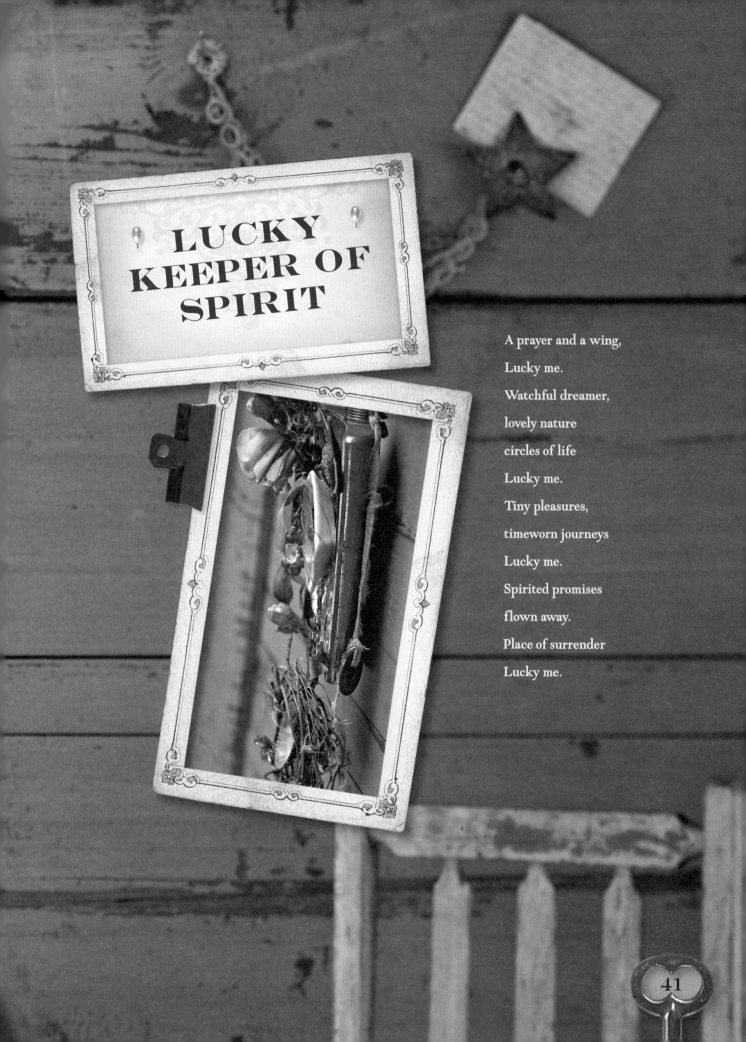

LUCKY
KEEPER OF
SPIRIT

A prayer and a wing,

Lucky me.

Watchful dreamer,

lovely nature

circles of life

Lucky me.

Tiny pleasures,

timeworn journeys

Lucky me.

Spirited promises

flown away.

Place of surrender

Lucky me.

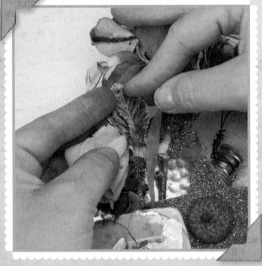

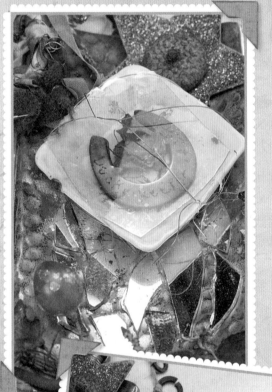

A simple wooden pant hanger from ages ago gets this one going, along with the vintage silver hammered flask. Once again, wire is my attachment of choice; heavy-gauge wire joins these two objects together to form my base for this piece. Hanging it to work on made it much easier to see the scale of what to add and what I was working with. I worked on the flask first, laying it down and gluing the shards of mirror onto the front of it with clear Liquid Nails, adding another wonderful texture to the silvery "keeper." Another layer was added with the antique square butter pat, front and center, with clear Liquid Nails as well.

As you create your work, think in terms of adding layers along with a good mix of textures to give your artwork depth and interest. Within the butter pat, I added a mother-of-pearl "horseshoe" buckle and a dried rose bud, then topped it with an irregular-shaped piece of mica, and loosely wrapped fine-gauge silver wire around it, framing it with a sense of importance—as the center of this piece.

Experimenting with attachments is how I found my favorites; after a while, you get pretty good at choosing the ones that will work best with your materials. Tying elements onto your work is another simple way to add finds to your art, like I did with the torn periwinkle strip that hangs from the neck of the hanger; from it, I was able to add some more adornments by tying onto it. Once you get the core elements on, they will serve as an anchor for attaching other things. The rest of these elements were basically tied or wired, hidden and tucked in with a clear glue, such as Liquid Nails or E-6000 glue.

LUCKY KEEPER OF SPIRIT

TASK FOR TAPE

When combining vintage millinery flowers or leaves together, secure them with floral tape, found in the artificial flower section of your favorite craft store. This tape comes in white, green and brown, and it works well when attaching them to a branch or other elements. To secure it, and add a little more texture, I also like to add some wire around the tape—it gives it a finished look.

PERSONAL PROMPTS

I SEE THE POSSIBILITIES

WHENEVER I AM CREATING, I FEEL

WHEN I LET "WONDER" INTO MY LIFE, I

43

LEGEND

1. Wooden hanger—supportive
2. Velvet bird—mother
3. Old laundry pin—keeping things together
4. Spiral shell—growing
5. Silver flask—home
6. Mica star—watchful dreams above
7. Millinery flowers—softness of nature
8. Faded pearls—timeworn
9. "Horseshoe" mother-of-pearl buckle—lucky me
10. Antique butter pat—heart
11. Mirror shards—looking within
12. Rosary—prayer
13. Washers—circles of life
14. Nest with hollow shell— emptiness/home
15. Wool blanket—warmth of home
16. Flower button—tiny pleasures
17. Key—openness

Consider each of the objects here, and jot down your thoughts about what each might represent to you.

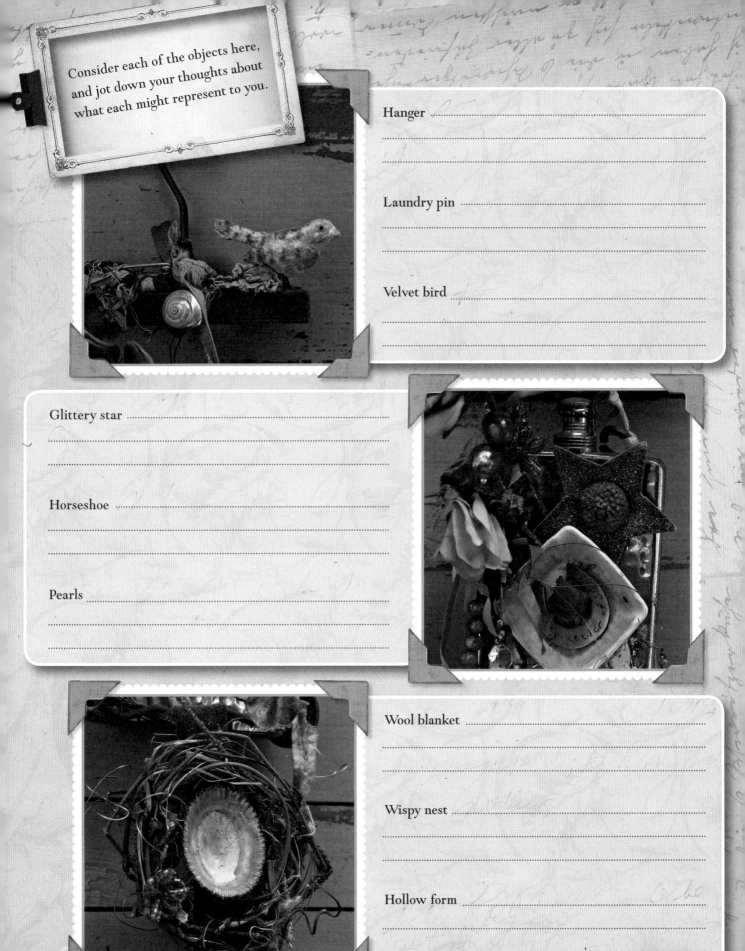

Hanger ..
..
..

Laundry pin ...
..
..

Velvet bird ..
..
..

Glittery star ...
..
..

Horseshoe ...
..
..

Pearls ..
..
..

Wool blanket ...
..
..

Wispy nest ...
..
..

Hollow form ..
..
..

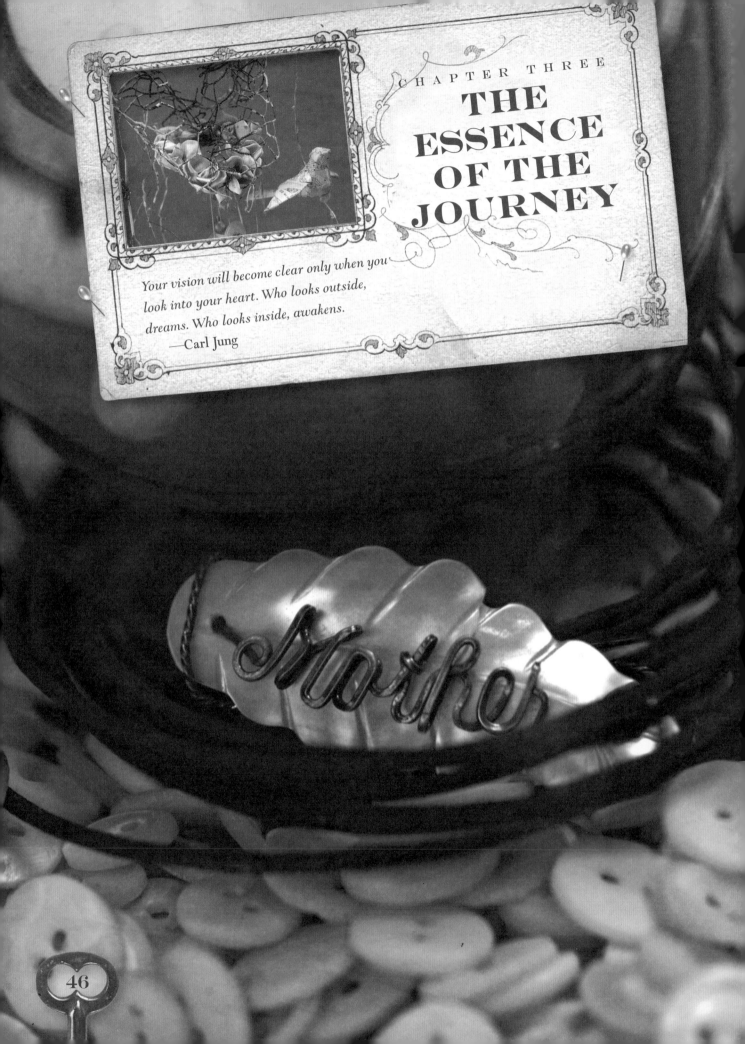

THE ESSENCE OF THE JOURNEY

Your vision will become clear only when you look into your heart. Who looks outside, dreams. Who looks inside, awakens.

—Carl Jung

SEEDS OF AWAKENING

An awakening implies that it's preceded by sleep, right? I don't know about you, but I've felt a loss when I'm not walking through life, as it were, fully awake, and I've denied myself abundance and clarity because I have not shown up in my life. There have been times when I was sleepwalking right through my creative garden. I know the soil is dry, and weeds have overtaken the place of flowers in full bloom. I do have a few ideas of the why's—the everyday pulls of to-do's: kids, home, work, and by the end of the day there isn't enough water in the well to fill my cup, let alone to water the garden! Does this sound at all familiar? I just know that when sleepwalking does occur, that's when I need to be out there laying the groundwork, gathering seeds of inspiration and then releasing them in the rich soil of my soul.

When have you ever been on a journey when there weren't any discoveries? They go hand in hand, don't they? Discoveries abound in the present moment; we just have to unpack our bags and settle in to the here and now. I know that whenever I'm visiting a new place, I'm so excited to be in that very moment, always wishing that time would stand still, and all the while hoping that I won't miss a thing. It's as if all of my senses go into this realm of magical overload. The air seems fresher, the food tastes yummier, the colors are glowing, but mostly the people seem to be more vibrantly alive. Why is that? It's all in the awareness of the moment that makes these new life experiences so enchanting.

And then there are places that we've circled in red on our life map—ones that we believe once we arrive at, this or that will be more fulfilling, or more lucrative, or we'll fit in more. These are all mirages— false dreams that rob us of where our discoveries are in the present moment. Once we shift our focus on the journey, with all its little side trips and funky hole-in-the-wall finds, and not the final destination, it's then that being at point A is the only point that matters. We can tackle point B when we get there!

AUTHENTIC EXPRESSION

When we catch ourselves comparing our artwork with someone else's, the temptation is always there to pick ours apart. It seems "less than," "not as good as," or we are intimidated by it. There is a huge difference in observing and being influenced by someone's work, and then proceeding to mirror their inspiration onto ours. So many times it's hard to tell one's own vision from another. The techniques that we all have had the opportunity to learn are there for us as jumping-off places that hopefully send us down our own paths to explore. Of course, as we all know, there is a place for learning or copying the technique the first few times until we get the swing of it, but after that it's up to us to ask ourselves some basic soul questions.

✦ How can I say and do it differently so my work speaks with my authentic voice?

✦ What will it take for me to find real meaning within my work?

✦ In what way can I challenge myself to see with new eyes and create with my own spirited sense of style?

✦ Are there alternative approaches to achieving new discoveries?

✦ How can I stop feeling intimidated by comparing my work to that of others?

Keep asking yourself the questions and then truly listen to the answers that come to you. Soon you will find the things that influence you, and your work will be ongoing with few boundaries. Once you begin down this road of self-discovery, you will start to notice little nuances in your work that speak directly to you, that have your signature style attached to them.

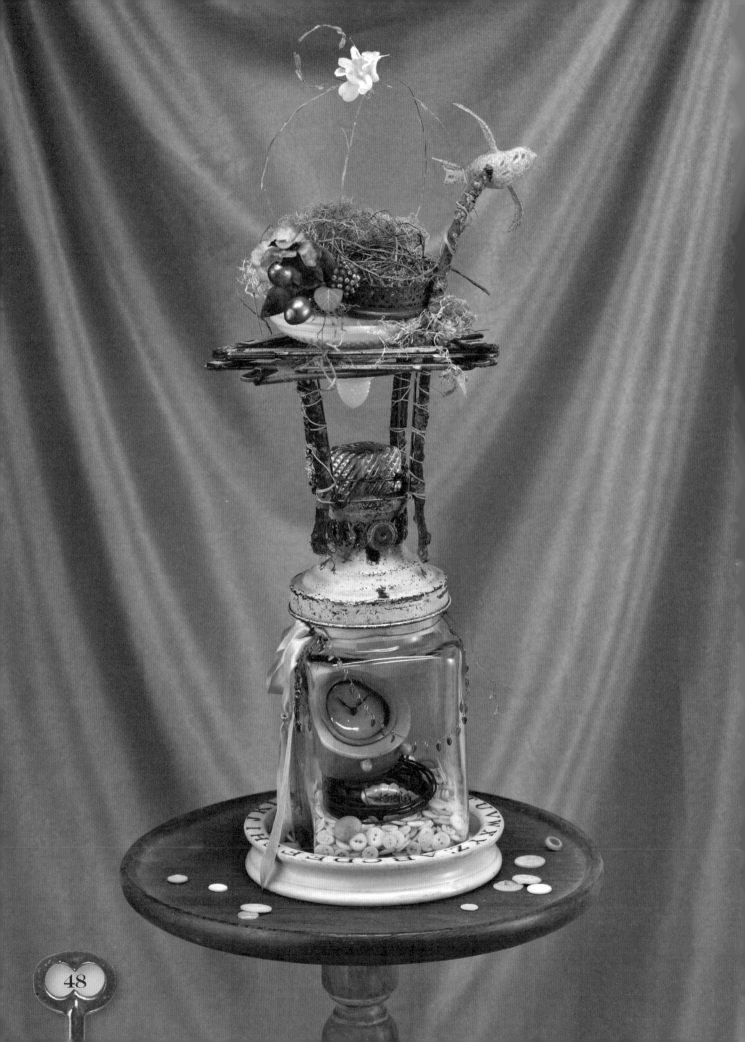

48

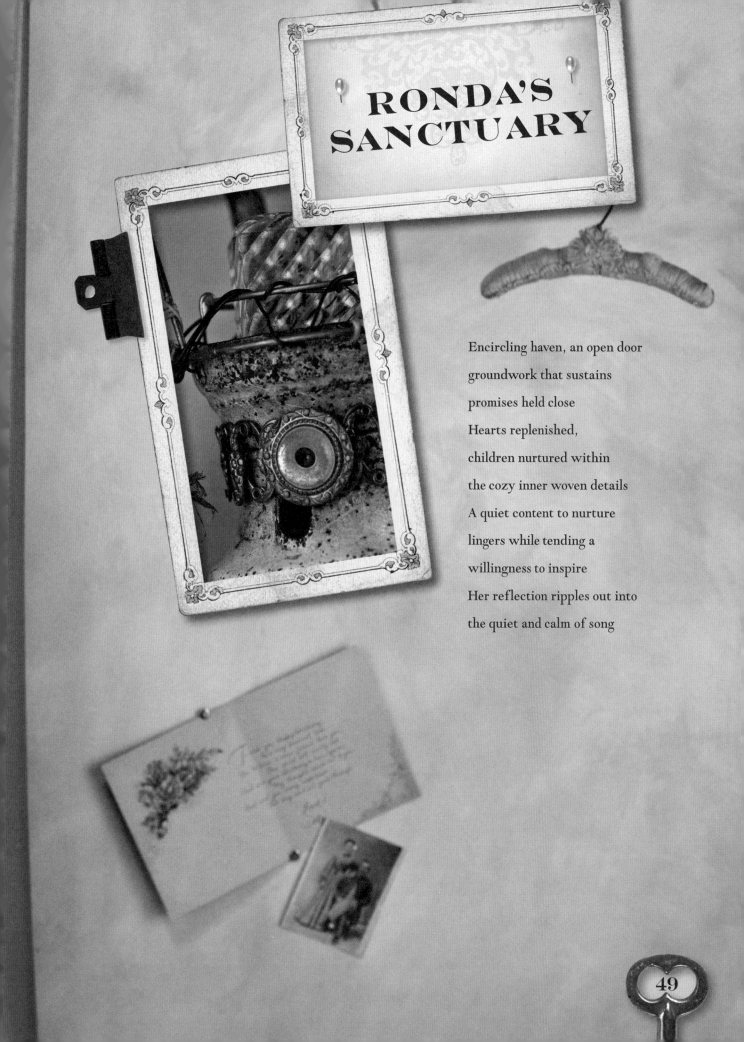

RONDA'S SANCTUARY

Encircling haven, an open door

groundwork that sustains

promises held close

Hearts replenished,

children nurtured within

the cozy inner woven details

A quiet content to nurture

lingers while tending a

willingness to inspire

Her reflection ripples out into

the quiet and calm of song

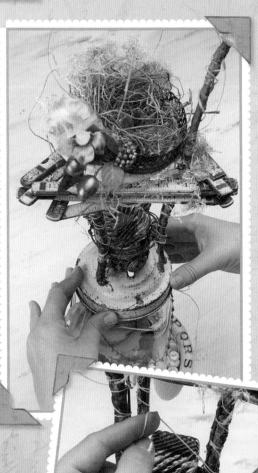

As I sit here on this unusually warm February day, writing at my backyard picnic table, the warmth of the sun is shining, and it is such a welcomed and appreciated gift, just as Ronda, my friend, is to me. Last summer, I had gone to her home to house sit while she and her family were away on vacation. Never having been there without anyone else there, being alone in the house was, at first, a little different. I had always felt the calm in her home when I had visited before—always with kids, and life happening all around—always love within. What I felt there alone was the same lingering love that is there when the home was filled with laughter, song and good cooking. (Ronda is a wonderful cook!)

I have a small collection of antique baby dishes, which began with one that was my mother's when she was a baby. Ronda gave the one used here to me for my birthday one year, and it has always sat on my coffee table filled with mother-of-pearl buttons—always a perfect reminder of her dear friendship.

When I began this piece, I nestled the antique jar inside of the dish and surrounded it with buttons, only to realize that that was going to have to be the last thing I would do to finish this piece off. It's not one that is easily moved about. But, it fit, and that's all I needed to know. I added some more buttons to the inside of the jar, along with a rusty old spring, a mother of pearl "mother" pin and an antique non-working celluloid clock. These were more or less just placed within and not secured in any way, but they fit together nicely, without moving around too much. The "lid" of the jar is really an old metal light fixture turned upside down, another favorite element that I

RONDA'S SANCTUARY

The twigs were fixed in place with waxed linen thread. I use a lot of this, too. It just seems to pull taut and gives a good secure hold on most items, not to mention it's something different than my old standby, wire! Atop of the twigs and at the bottom of the lampshade frame, I placed and wired the folding wooden measuring stick in a triangular shape with a small-gauged wire to a milk glass sugar bowl lid, again upside down. The tiny brass lamp element was the perfect base for the nest, with its lightbulb prongs facing upward to help hold the nest in place (somewhat). I added the papered wire dome with a wispy flower by simply pulling it through and twisting it to the decorative edging on the brass base. A vintage clip-on earring, old millinery flowers and fruit dot the outer edges for a finishing touch. Oh yes . . . the bird, which is another old find, was lightly wired to the branch that slightly turns outward.

use in my work. It too is just placed there securely atop the jar, not wired or glued. I felt that since there was a possibility that I may have to rearrange the contents of the jar at some point, I wanted easy access.

I had found this darling expandable gold baby bracelet online and discovered that it fit snuggly around the neck of the light fixture. I then struggled a little to find the perfect element for the opening of the metal fixture, but once I placed the square glass bottle stopper inside, I knew it was a keeper. I then wired with heavy-gauge wire the bones of a lampshade to the light fixture; I disguised it with twigs that I had collected from a special trip on the Washington coast.

Note here, I've discovered that whenever you add elements that have special significance to you, you will notice your work speaking to you in a very different way—much different than if it doesn't contain any sentimental attachments.

REMAINING UNATTACHED

Sometimes the pieces you create will not lend themselves to being moved around a lot, as is the case with this one. If you know you are going to have to ship one of your pieces, keep this in mind as you create!

PERSONAL PROMPTS

I'M NOTICING A DIFFERENCE WITH

I FIND MYSELF

MY TRUE CREATIVE NEEDS ARE

IF I SHOW UP, I WILL

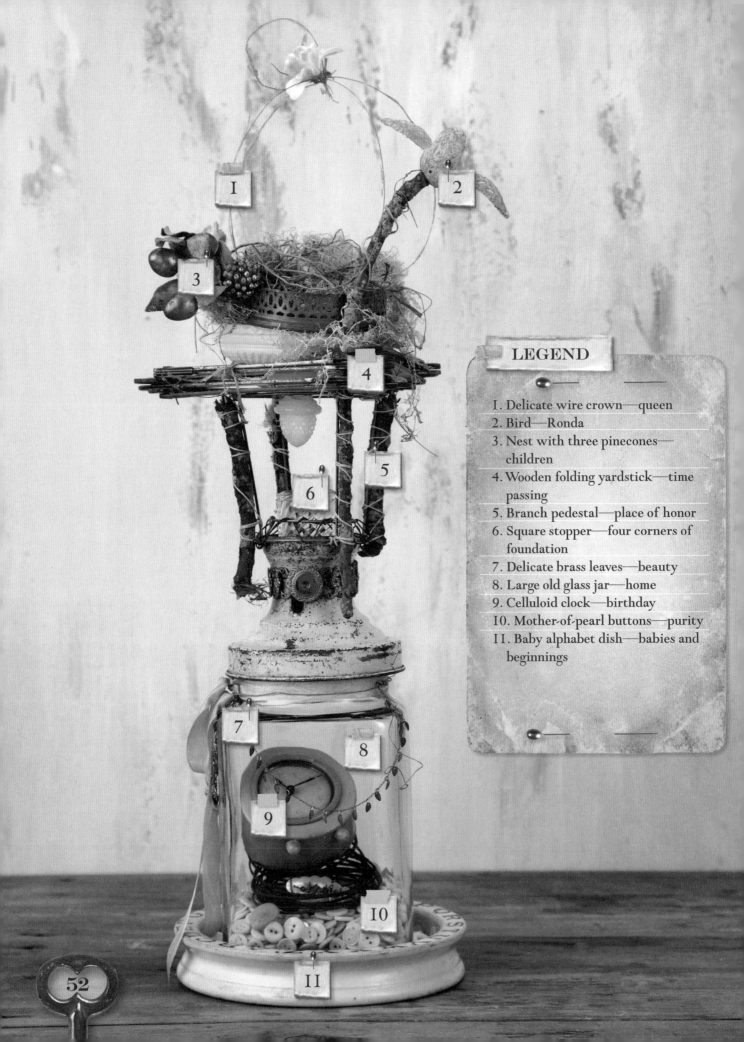

LEGEND

1. Delicate wire crown—queen
2. Bird—Ronda
3. Nest with three pinecones—children
4. Wooden folding yardstick—time passing
5. Branch pedestal—place of honor
6. Square stopper—four corners of foundation
7. Delicate brass leaves—beauty
8. Large old glass jar—home
9. Celluloid clock—birthday
10. Mother-of-pearl buttons—purity
11. Baby alphabet dish—babies and beginnings

Consider each of the objects here, and jot down your thoughts about what each might represent to you.

Nest ...
...
...

Pinecone ..
...
...

Stick ..
...
...

Clock ..
...
...

Glass jar ..
...
...

Wire spiral ..
...
...

Mother-of-pearl ..
...
...

Buttons ..
...
...

Mother ...
...
...

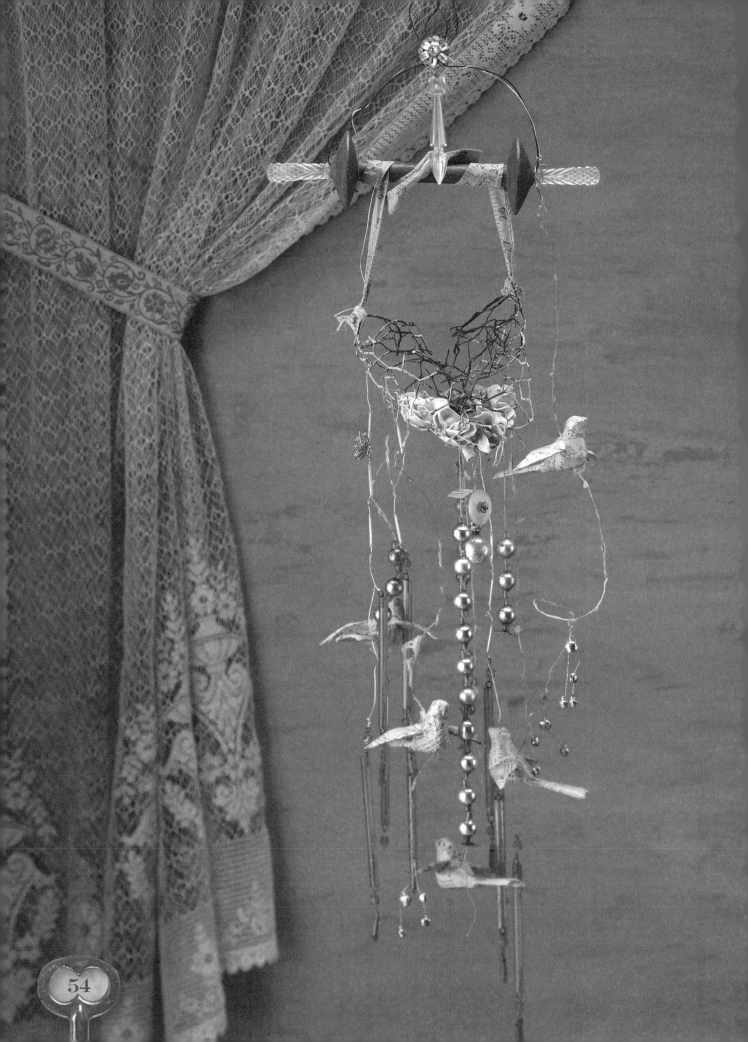

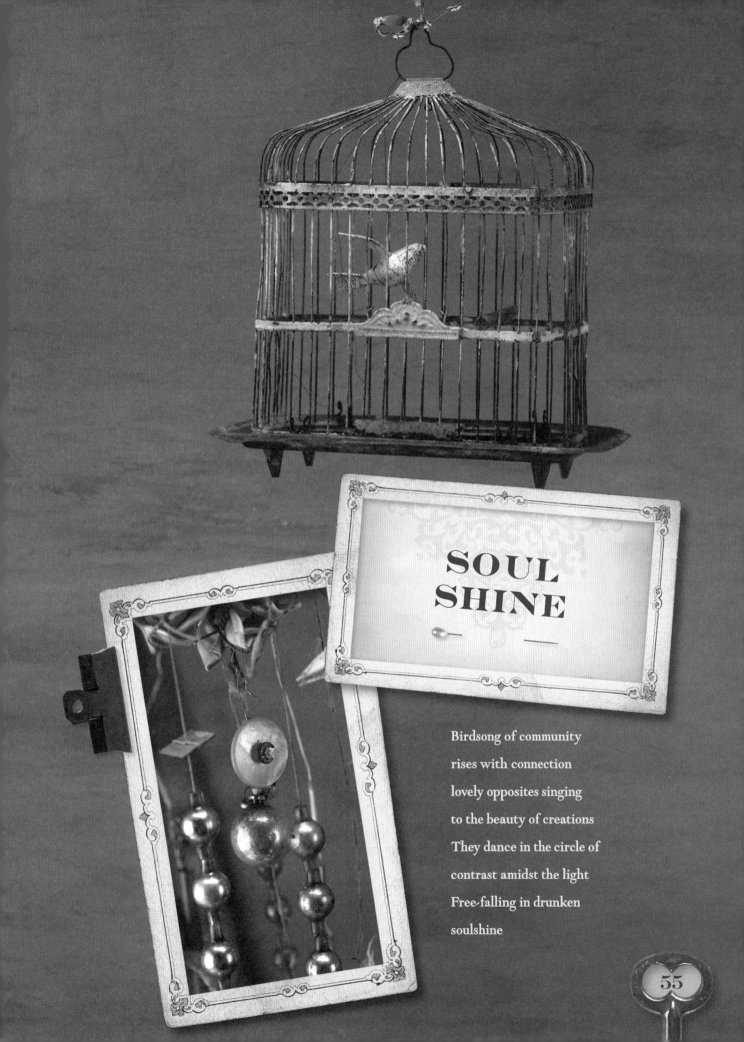

SOUL SHINE

Birdsong of community
rises with connection
lovely opposites singing
to the beauty of creations
They dance in the circle of
contrast amidst the light
Free-falling in drunken
soulshine

55

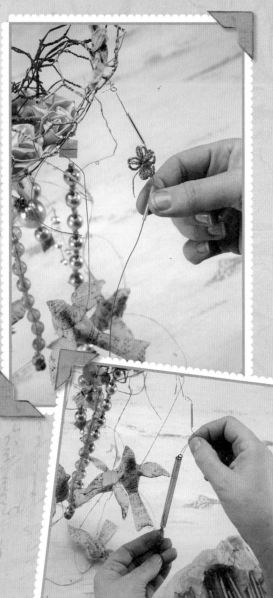

I quickly became friends with this one before it was ever put together. I just love each of the elements in this one so much. One of my vintage metal parlor baskets literally fell apart, and when it did I rescued all of the pieces, knowing that I'd use them with something. The rusty chicken wire was somewhat short and oblong. It was in the center of the basket to hold the flowers in place way back when, but when I folded it in half, it resembled a heart. Well, that was all it took for me to jump on this one. I saw the heart of the home, knowing that I'd add some type of nest sheltered within the open heart. I didn't want to use an actual nest, although I could've. I waited for the right inspiration to strike. It was some time before I found the perfect nest for this one.

I spotted an antique satin wedding hairpiece in a case at a local antique mall, and yes, I paid too much for it. After I purchased it, I didn't think of it for a while, but, once I did envision it inside the harsh contrast of the rusty chicken-wired heart, it was a keeper and would make the nest I'd been searching for.

I saw it as a mobile; then came the thoughts of how I would put it all together and what I would still keep my eyes peeled for. It wasn't long before the old spool made its way into this. From there, I découpaged the plastic bird light covers with old hymnal pages and suspended them with papered wire from a vintage Japanese lantern, another one of those great finds that will one day be all gone! Gorgeous amber chandelier prisms keep the little birds company, along with some vintage mercury garland with its little cardboard squares keeping the birds from falling off. When something that good is happening all on its own,

SOUL SHINE

I don't mess with it. There is no amount of altering to reproduce that charm.

This is a good time to tell you that I use a lot of Christmas ornaments and decorations, mostly in their "as-found" condition. Sometimes I will alter them if they are too cheesy. The tiny silver bells are new, another Christmas-department find at the local craft store. To finish off the hanging elements of this piece, I simply added more textures with the vintage cloth measuring tape and some silver jewelry wire to secure it better. Once I threaded the heavy-gauged black wire through the spool and looped it up and around to make the actual hanger, it was just a matter of adding some adornments to finish the piece off. So . . . a rhinestone button to dress up the peak of the hanger, and a funky

plastic prism dangling down from it, seemed to make it complete, until I spotted some plastic, equally funky corn-on-the-cob holders to finish off the sides of the wooden spool. It's fun to add these unusual finds, to hear people say, "What's that?"

This piece is a good example of the use of repetition. Sometimes multiplying just a few elements goes a long way and truly helps send a message.

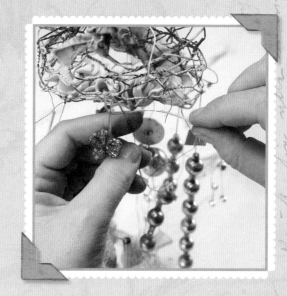

SUPPORT SYSTEM

Whenever you're constructing a mobile or any hanging artwork, make sure to use a heavy wire. Along with the cloth measuring tape, I added a thin silver wire to help secure it. Just remember to test the weight of the items that the hanger is holding, and keep the weight at the bottom lighter.

PERSONAL PROMPTS

THE CREATIVE ESSENTIALS OF ANY DAY INCLUDE

AS AN ARTIST, I ACCEPT THAT I AM UNIQUE IN MY

I WILL TREAT MYSELF DAILY/WEEKLY TO

LEGEND

1. Plastic prism—funky
2. Wooden spool—simple order
3. Corncob holders—hold on
4. Cloth tape measure—measure of time
5. Wire heart—lovely opposites
6. Satin headdress—circle of love
7. Beaded silver flowers—patient beauty
8. Tiny silver wire—got your back/support
9. Rhinestone button—sparkle
10. Silver mercury garland—connection
11. Tiny silver bells—sweet sounds
12. Songbirds—community
13. Gold prisms—soul shine

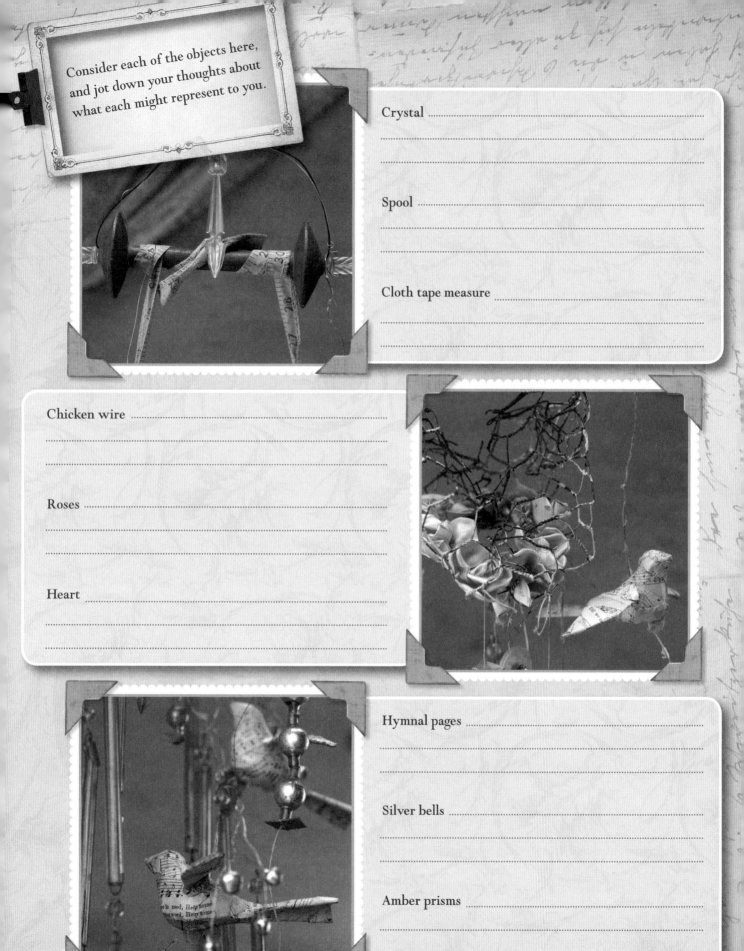

Consider each of the objects here, and jot down your thoughts about what each might represent to you.

Crystal ..
..
..

Spool ..
..

Cloth tape measure ..
..
..

Chicken wire ..
..
..

Roses ..
..
..

Heart ..
..
..

Hymnal pages ..
..
..

Silver bells ..
..
..

Amber prisms ..
..
..

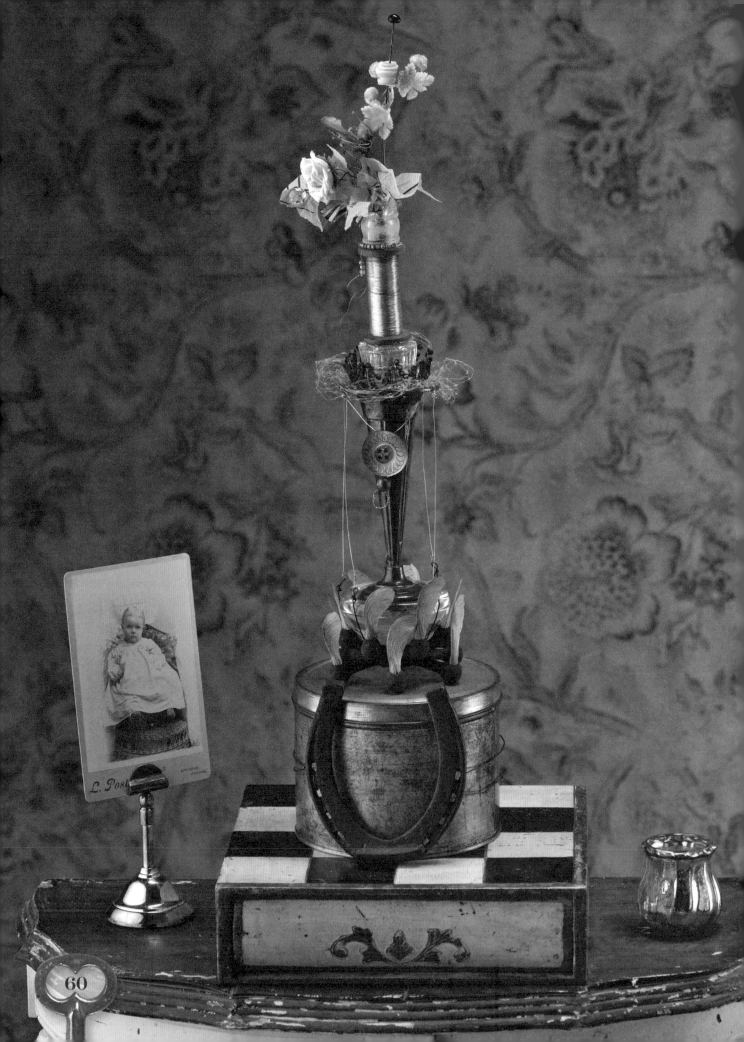

TROPHY LIFE

There is a place
that resides within,
somewhere between
the spaces of magic
and security,
of being kind
and industrious,
a space of growth
and good luck.
It's a balancing act . . .
and the winner is!

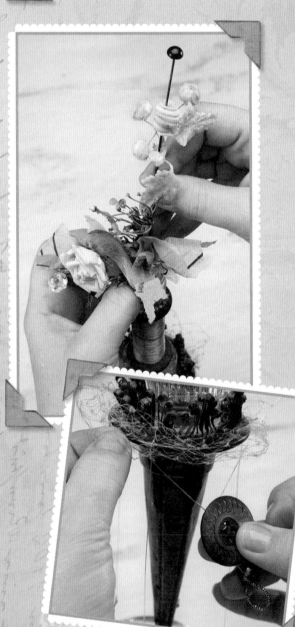
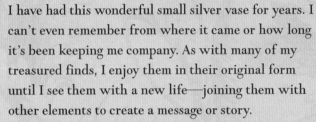

I have had this wonderful small silver vase for years. I can't even remember from where it came or how long it's been keeping me company. As with many of my treasured finds, I enjoy them in their original form until I see them with a new life—joining them with other elements to create a message or story.

A fifty-cent find during a Galveston jaunt (an object that almost had an outer-space look to it) had been just sitting there for years, the lady behind the counter told me. This black-iron, round-spoke mystery object with little holes at the end of each of its many prongs looked like it might be from an antique stove or heater element. Nevertheless, it finally made its way as the perfect base for an old glass paperweight, which, once turned upside down, fit the base of the vase like a glove.

As each find was added, the silver vase was gaining more stature, giving her more ground to be dubbed as a true trophy. (I might add here that someone else who saw this piece completed, envisioned one of those old-fashioned swing rides at the carnivals that came to town. So, it's all in the eye of the beholder. Once she made mention of this, I could imagine a completely different story being spun—no pun intended!) To secure the vase to the paperweight, I used a small amount of clear Liquid Nails.

I drilled small holes around the lip of the silver vase in order to thread silver jewelry wire through to secure the vase to the iron piece at the bottom. The "wings" are from a huge silver-leaf maple tree in our backyard that was home to my youngest son's tree house. He and I would climb up there when he was just a little boy, and we would play this game of trying to predict where

TROPHY LIFE

these would land once we'd let go of them, letting them fly. This is just one of the simple yet priceless memories that I will always cherish with him. When using these seedling wings, I always coat them with a thin layer of clear matte acrylic gel medium, just to help strengthen them a bit, as they are so fragile.

The old metal tin was a Goodwill find for a quarter, and the old horseshoe is one of many I have around for good luck. In keeping with the primitive feel, a heavy wire is wrapped securely around it, holding it onto the tin. The antique gilded Florentine box and the round old tin are complete opposites; I try to incorporate contrast in my work, just as in life. I didn't attach the tin to the box—only set it there, not wanting to alter the box or take away from its value.

Once the bottom part was assembled, the top part seemed like the icing on the cake. Some old millinery netting that I rescued from an old hat added some texture to the lip of the vase, and the glass piece is from a vintage coffee percolator lid. The wonderful spool of silver thread is from a friend's vintage Etsy shop. I unwound it just a bit, and then I added a sliver of aged pearls to the bottom of a broken bottle, serving as the foundation for the crowning touch of old white millinery flowers. An antique hatpin with threaded tiny mother-of-pearl buttons weaves its way down

through the spool and helps hold the entire upper portion in place.

The pattern piece and the striped fabric pull a little of the black and cream colors up to the top. Still not feeling quite finished, it seemed as if something was missing. The large carved mother-of-pearl button, in her gorgeous, faded, pearlescent-and-coffee colors, was the perfect "center," along with the tiniest steel-cut beads that formed yet another circle just below it. A simple gold bead separating the two seemed to complete the trophy.

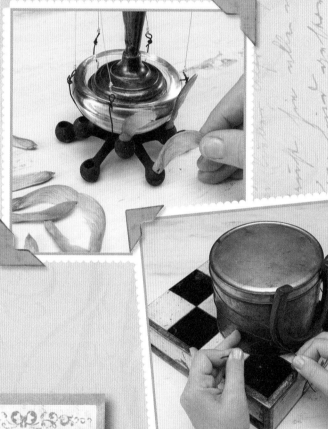

PERSONAL PROMPTS

I WILL NOT CENSOR

I AM OPENING MY EYES TO

WHENEVER I AM IN THE MOMENT, I

LEGEND

1. Hatpin—security
2. Velvety millinery flowers—softness/kindness/beauty
3. Pattern tissue—industrious
4. Broken bottle—disappointment
5. Tiny pearls—beautiful magic
6. Spool of silver thread—keeping things together
7. Netting—transparent nest
8. Steel-cut beads—collected memories
9. Tiny silver wire—delicate balance
10. Mother-of-pearl button/center—the heart
11. Silver vase—structure
12. Wings/seeds—growth
13. Paperweight—grounding
14. Metal stove element—circle of wings
15. Round metal tin—stability
16. Horseshoe—good luck
17. Florentine box with drawer—a place of importance

Consider each of the objects here, and jot down your thoughts about what each might represent to you.

Hatpin ...
...
...
...

Tissue paper ...
...
...

Bottle ...
...
...
...

Netting ...
...
...

Vase ...
...
...

Clear glass ..
...
...

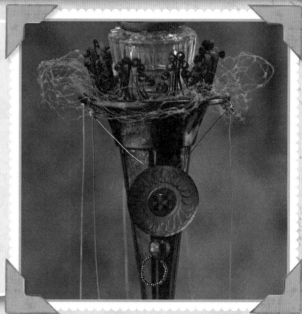

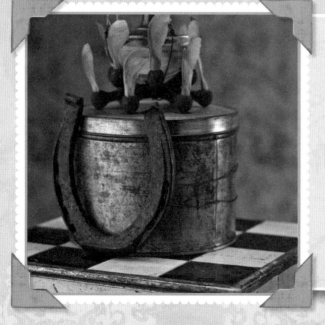

Metal tin ...
...
...

Seedings ..
...
...

Iron ...
...
...

SOULFUL INQUIRY

Throw your heart over the fence and the rest will follow.
—Norman Vincent Peale

Somehow as I sit here writing this section on inspiration and how to quiet that inner critic who seeps into our thoughts ever so slyly and immediately, I feel the fear. I am blank. I am numb. It's happening to me right in this very moment. I feel those self-doubt bullies are coming out to create havoc on my inspirational playground. I can hear their voices whispering yucky nothings in my ears: "Who do you think you are? You're not a writer. Are you really even an artist?"

I find myself questioning how I can convey this message of inspiration when I myself feel as if something has its grasp on me. My answer, thankfully, comes immediately to my mind: "By showing up, that's how." And so will you.

It always takes me to a curious place when I hear people say they aren't creative. I believe that fences were built at some point when we were all very young, setting up these unfounded boundaries. The whole notion that "so-and-so is creative and I'm not" is one that gets told in our heads way too early. As if we are going to get graded on our ability—hogwash. There isn't a report card on creativity. Only if you're the one doing the grading will there be comparisons made. Teetering on that fence separates us from the others on this meaningful playground. I say it's time to tear down those fences that keep us from experiencing creativity or claiming our place on the playground.

I remember the first time I compared my artwork with another's. I was in second grade, and my teacher held a paper Easter-egg-decorating contest. She gave us each a huge piece of drawing paper that she had cut into a giant egg shape. It was that old manila paper that had a great texture! Two "winners" would be chosen— a girl and a boy. Up until then I had never thought in those terms, never thought of "winning" with my artwork or that it could be "better" than anyone else's or vice versa. I ended up as the "girl winner" of that creative competition, at the age of eight. I gave the paper egg to my grandma, who then proceeded to frame it and hang it in her home. This gave me a sense of pride that I hadn't ever considered. It was definitely a double-edged sword—one that made me feel good, but which, from that point forward, put me into that comparison mode. So I'm here to help you tear down that fence on the creative playground—the one that has you comparing your gifts to others'.

Before I had really shown any of the type of artwork you see in this book to anyone, I was asked what kind of art I did. I answered, "Collage." When this person saw my work, she corrected me and told me it was *assemblage*! Up until this point, I hadn't even known what to call my own work. I had only given it away to friends and family or kept it. That was in early 2004! Since that time I mustered up the courage to accept showing my artwork along with three or four other artists at a wonderful shop on the first-Friday art walks in our city. I did this for three months, selling a few pieces and gradually building up a little bit of courage along the way. Even though these first steps were scary, and my very critical self was working overtime, I decided to fire her and to accept a much more qualified and positive companion into this heart and soul of mine—an angel.

If you're anything like me, I know you've gotten in your own way so many times, stumbling and falling over your fears. But remember that you have your own personal nonjudgmental angel who, if you will listen, doesn't lag too far behind you and will give you a good talkin' to, before nudging you on your way and encouraging you to get right back up. It's never good to stay down too long.

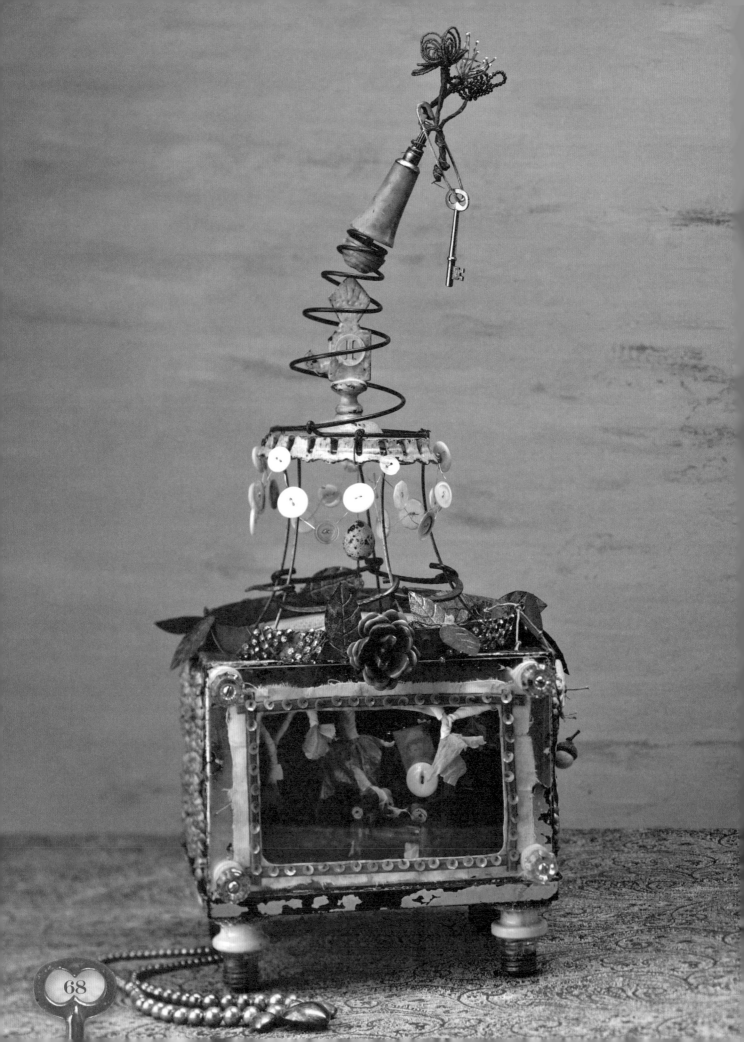

CROWN ME

If only for one hundred

or so May days

looking inside out

crown me queen of wishes

Watching outside in

a show of possibilities

Uncharted waters below,

tiny lightening bugs shining the way,

as magic swirls above,

Make wishes by night,

make peace by day

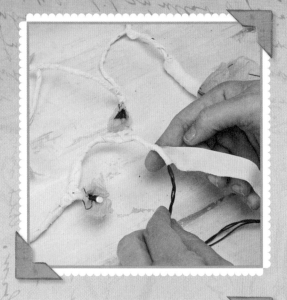

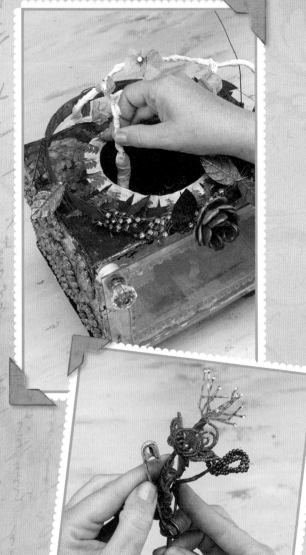

There are times when I just wire a few pieces together and set them somewhere in the studio, not knowing which finished piece they'll end up in, just that I like them together. That was the case with this piece. The bedspring and the little plastic handle element (to this day, I have no clue what that thing is!) were joined together, and then I just sat that atop a vintage iron hat stand. So, it was like having a little clown keeping me company on my work table, until one day I saw a crown instead of a clown . . . who knows, maybe I was feeling a little bit "Queenie" that day.

I began elaborating on this concept, adding the vintage iron plant holder, turned it upside down, and began wiring those together, which led me to the bones of a lampshade. At this point, I was only thinking of the crown. The metal box had been set aside, due to a bad collage job I had forced on it. I was frustrated with that and had no clue as to what, if anything, I'd ever do with it. For some reason I laid the crown on top of it because it was too top-heavy for the old hat stand. In that moment, I saw it as finding her home. Then it was just a matter of playing off that theme. The metal box had come with this shiny peely material on it, and it had a hinged lid. I really loved it just as it was, but I couldn't resist marrying these two great elements together.

For me, the box always spoke of a diorama—you know like the ones we made in elementary school, usually housed within a shoebox? Playing off the words "crown me," I added a checkered floor with mirrored tiles and, of course, a throne (which, for me, had to be something that was nothing fancy—something with some earthiness to it). When I spotted a little

CROWN ME

twig chair that used to be an ornament, I sat it inside with some aged hem tape in my favorite color, added a mother-of-pearl button onto the back and the sweet face of a woman tintype nestled in as the head. Hence, I created my vision of what being a queen might look like in my world.

Framing the "screen" with torn fabric medical tape, narrow vintage velvet ribbon and chartreuse sequins (resurrected from one of those old beaded fruits from the 1950s), I then topped it off with a piece of Plexiglas, with holes drilled at all four corners to attach it to the box. The glass knobs added yet another layer and more weight to the front, helping to balance out the heaviness of the top. The tiny shells were an afterthought, as I decided that I wanted to add a bit of the ocean to her. I adore old sailor art, and these seemed to give the piece a touch of that.

The large brass ring on top acted as the perfect finishing touch to the crown. I embellished it with a beautiful antique rhinestone-studded element that I simply wrapped around it and secured with 22-gauge silver jewelry wire. The earthy, tarnished leaves and one of my favorite pins that I used to wear on one of my favorite vintage swing jackets just seemed at home right there, front and center. The center cutout of the top of the box helped me to add some more light to the inside, plus helped me to secure the wires that held it all together. Tiny battery-operated lights that have been softened with aged interfacing dangle within, like little lightening bugs twinkling above—childhood memories! Five-pointed stars, as I've mentioned before, are something I just love to incorporate, representing my home state of Texas and my five children (and, in this case, another ocean reminder!). As you work on your assemblages, and in your gathering, you'll undoubtedly have these personal shards that will act as your signature, too. It's what makes your work uniquely yours.

TRIAL RUN

Work backwards! If possible, do a mock set up before permanently attaching your elements together. I'll even do a quick rough sketch and make side notes to myself as I think of things as I go along. You will save yourself some time in the long run.

PERSONAL PROMPTS

I AM INDULGING IN

I AM MAKING A SHIFT TOWARD

SELF-DISCOVERY MEANS TO ME

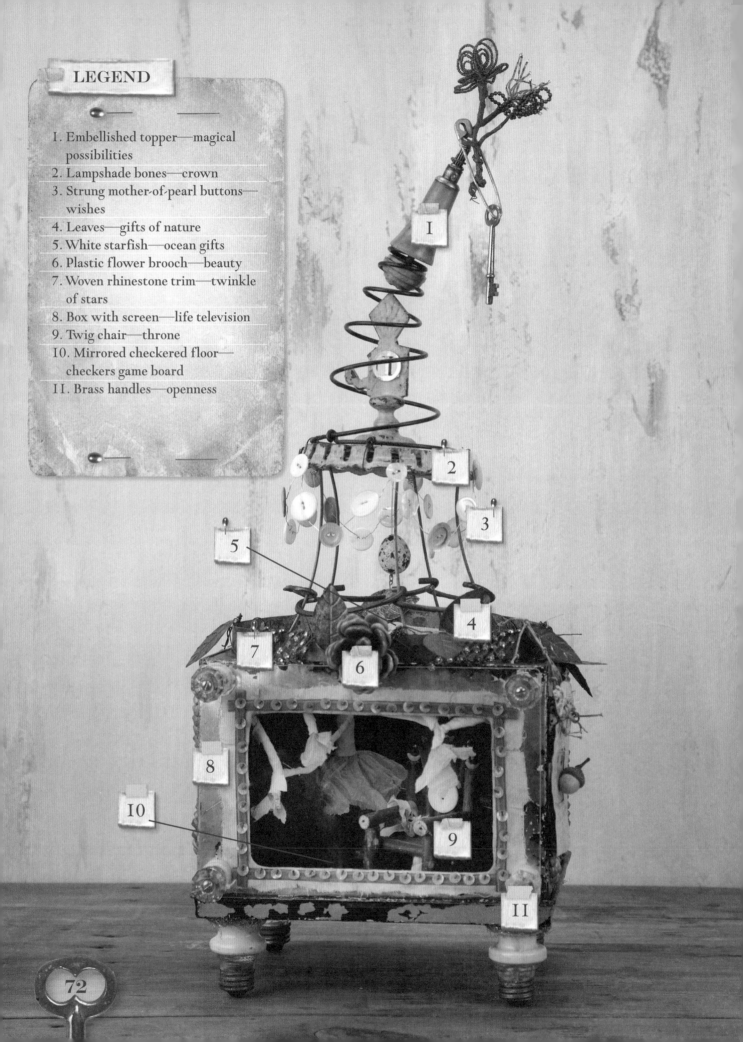

1. Embellished topper—magical possibilities
2. Lampshade bones—crown
3. Strung mother-of-pearl buttons—wishes
4. Leaves—gifts of nature
5. White starfish—ocean gifts
6. Plastic flower brooch—beauty
7. Woven rhinestone trim—twinkle of stars
8. Box with screen—life television
9. Twig chair—throne
10. Mirrored checkered floor—checkers game board
11. Brass handles—openness

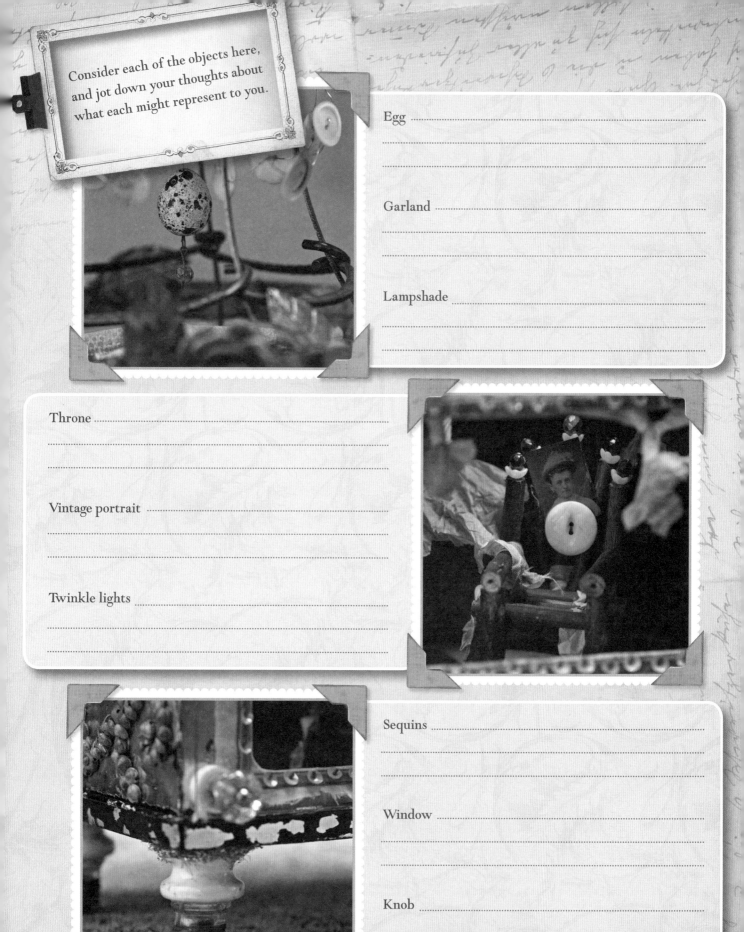

Consider each of the objects here, and jot down your thoughts about what each might represent to you.

Egg ..
..
..

Garland ..
..

Lampshade ..
..
..

Throne ..
..
..

Vintage portrait ..
..
..

Twinkle lights ..
..
..

Sequins ..
..
..

Window ..
..
..

Knob ..
..
..

73

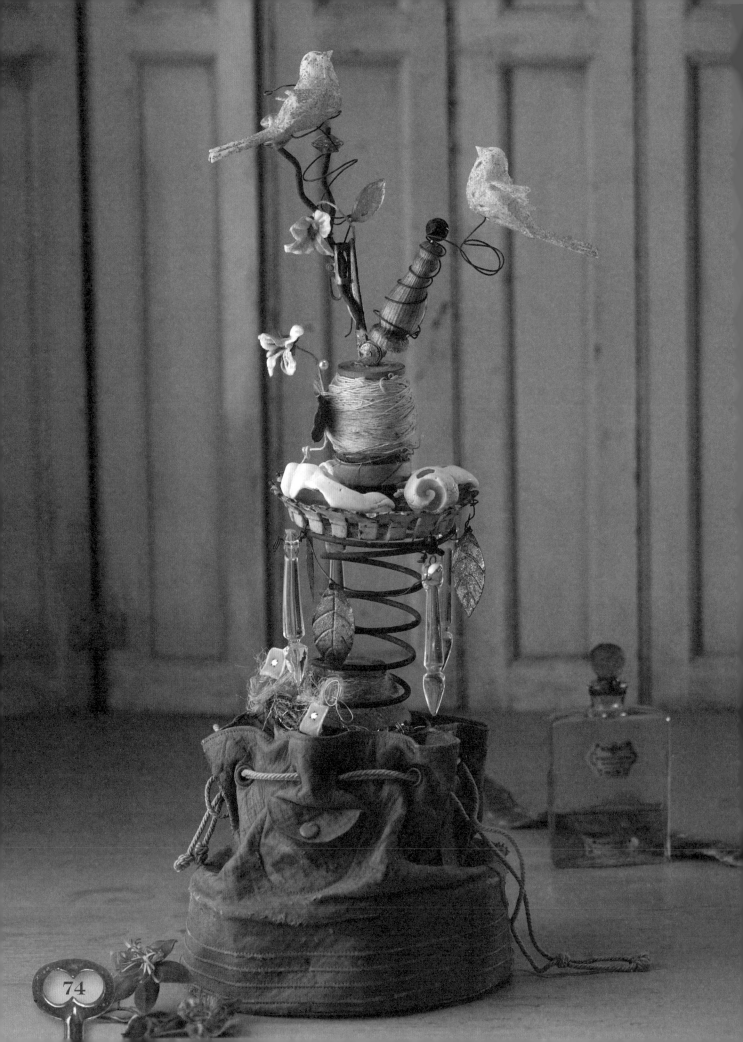

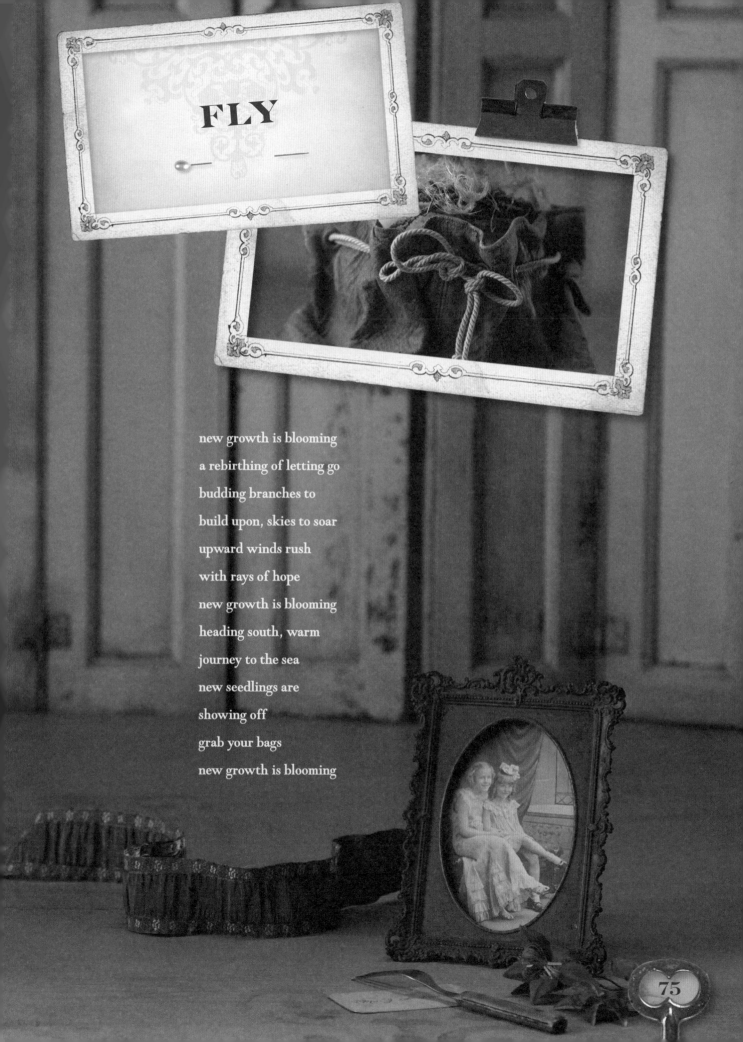

FLY

new growth is blooming

a rebirthing of letting go

budding branches to

build upon, skies to soar

upward winds rush

with rays of hope

new growth is blooming

heading south, warm

journey to the sea

new seedlings are

showing off

grab your bags

new growth is blooming

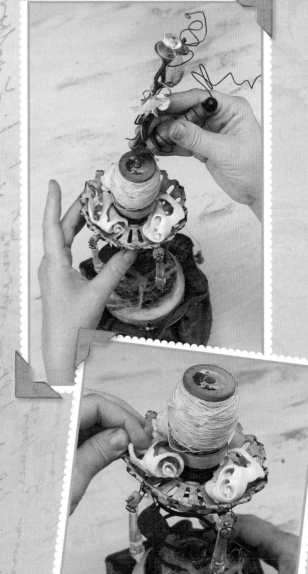

As I watched the seagulls, I thought: "That's the road to take; find the absolute rhythm, and follow it with absolute trust."
 —Nikos Kazantzakis

Like two other pieces in what I refer to as my "nest trilogy," I knew birds were going to be the common denominator in this chapter, which is a reflection of my empty-nest stage. So, with this in my mind's eye, I set out to weave in new elements, but in keeping with the theme.

The base is where I usually begin and then build from there. This piece was no exception. Under the vintage soft-leather drawstring purse is a domed glass lampshade that I connected to the metal fixture using its existing holes and screws.

Thinking that I needed to soften the effect of too much glass, I got the idea to slip the shade into the purse and gather it about, creating another texture and new meaning to the piece. I then wired the spring with heavy-gauge wire onto that same metal base.

The creamy scalloped iron saucer is from an old lantern holder that had broken off from its swing arm, and having those cutouts made it perfect for wiring onto the spring. I hot-glued the spool of thread down in the center of the iron stand and pinned a little nosegay of vintage leaves, a smooth pearly button and sweet velvety violets sprouting from its center, bringing the eye up, up, up to the birds flying away.

FLY

Since I like to add a bit of an ocean element to my work, the spiral shells were placed at the base of the spool. I disguised a drawing compass with part of a long satin tassel that slipped on like a glove, and then topped that with a spring effect using wire. It fit nicely into the hole in the top of the spool of thread.

This "piling on" of layer upon layer created just a bit more interest and depth, not to mention a jumping-off place for the birdie to fly! Glass amber and clear circular beads were placed onto a couple of rusty things (I have no idea what they were originally used for, but they worked for this!).

The earthy leaves were added to contrast with the crystal prisms that dangle from that great old iron piece. A little snippet of netting with tiny squares of pale blue velvet, tacked with baby rhinestones, was added at the bottom to give the illusion of fluffing the nest. The final touch? I added the birds with heavy wire that curls around their base like an egg holder.

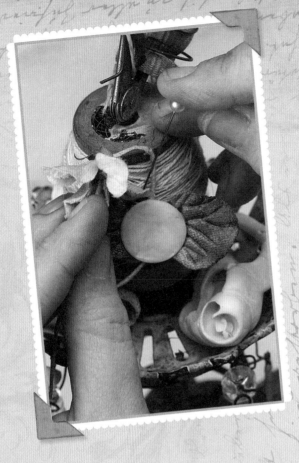

HIDDEN TREASURE

Find places to add personal elements that are hidden—notes and keepsakes that find a secret place, like a pocket, or in the bottom of a purse—a time capsule of sorts! Whenever I'm gifting or selling my work to someone else, I always tell the recipient that they too may continue to add their own personal elements and mementos to the piece. This gives a more personal spin to the artwork.

PERSONAL PROMPTS

I WILL CHALLENGE MYSELF BY

IN WHAT WAYS DO I SHOW UP FOR MYSELF IN THIS EXPRESSIVE LIFE OF MINE?

THE BENEFITS FOR MY FAMILY OR FRIENDS WHEN I GIFT MYSELF PERSONAL TIME INCLUDE

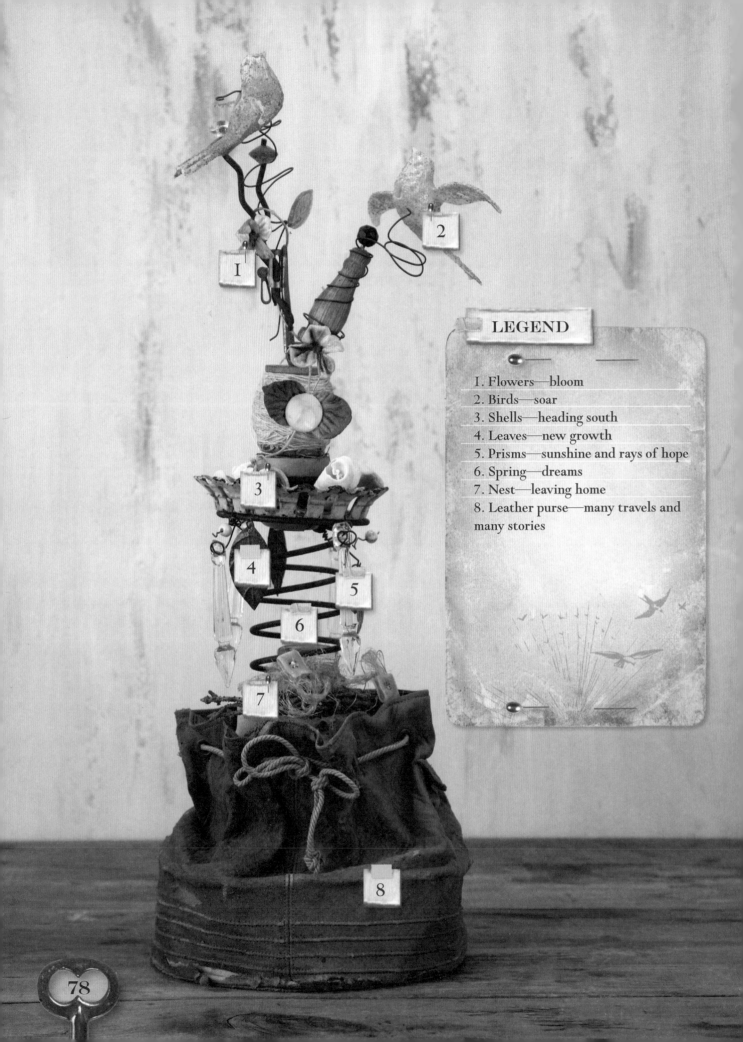

LEGEND

1. Flowers—bloom
2. Birds—soar
3. Shells—heading south
4. Leaves—new growth
5. Prisms—sunshine and rays of hope
6. Spring—dreams
7. Nest—leaving home
8. Leather purse—many travels and many stories

Consider each of the objects here, and jot down your thoughts about what each might represent to you.

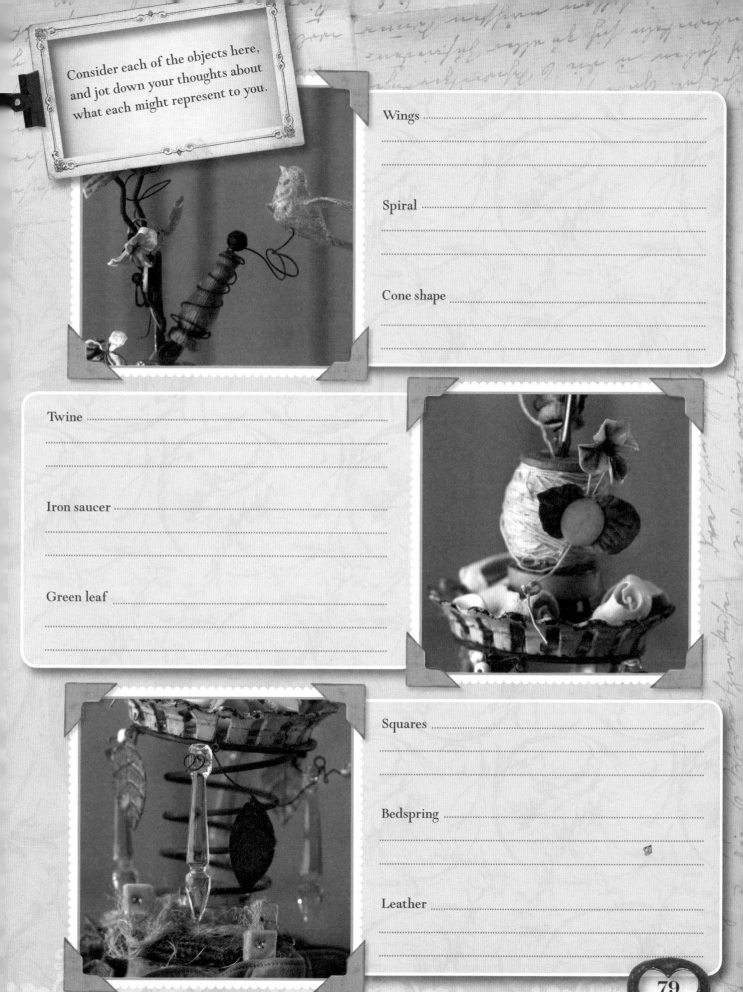

Wings ..
..
..

Spiral ..
..
..

Cone shape ..
..
..

Twine ..
..
..

Iron saucer ..
..
..

Green leaf ...
..
..

Squares ..
..
..

Bedspring ...
..
..

Leather ..
..
..

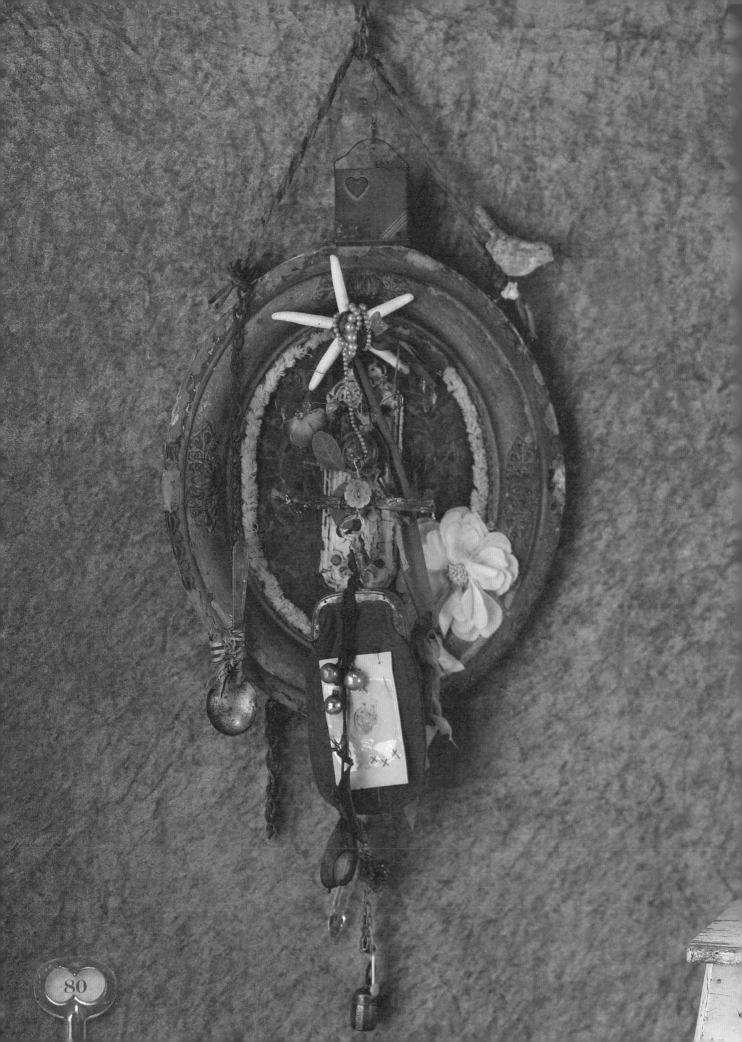

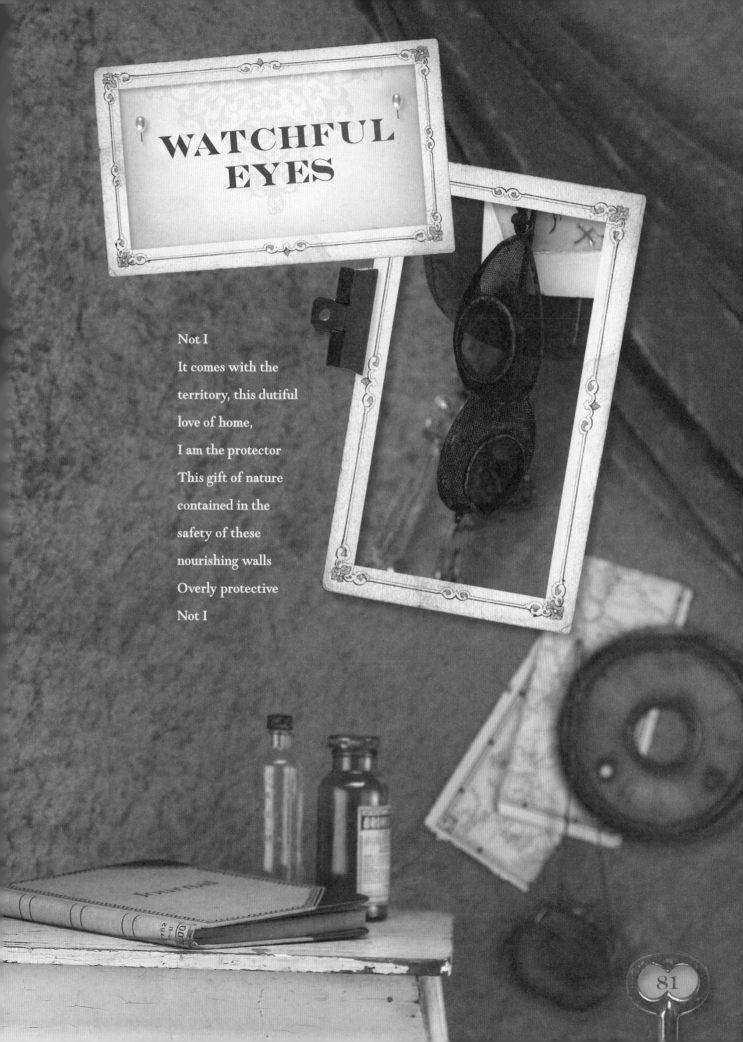

WATCHFUL EYES

Not I

It comes with the

territory, this dutiful

love of home,

I am the protector

This gift of nature

contained in the

safety of these

nourishing walls

Overly protective

Not I

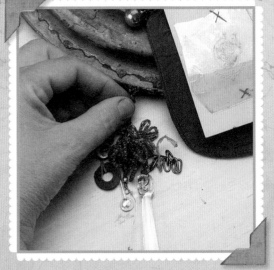

This piece is one of those that has evolved over what seemed to be a long period of time. It's what I love about working with this form of art—just the idea that it evolved like a beautiful room that has layers of time and travels mixed in. I had laid the groundwork with the gold peely and chippy frame, the doorplate and a few other elements, but it never seemed quite complete for some reason or another.

Once I landed the wonderful meshed eye goggles with their amazing peacock-blue lenses, it seemed to settle into itself more freely, and I felt the story could unfold. I also had the other half of a lovely Victorian photo album cover, left over from another piece I had done earlier in the year, and thought it may be a perfect fit with the hollow frame. I tacked it onto the back with upholstery nails. (I should mention here that these antique photo albums with their crushed and burnt-out velvets are one of my all-time favorite things to use, but I never deface one that is in excellent, or even halfway-good, shape for my work. I just cannot seem to tear that history apart.)

I then tried to figure out the mechanics of how the piece would stand or hang. Years ago, I found a box of old partially painted and perfectly tarnished cup hooks in a variety of sizes. I screwed the cup hooks into the top of the frame on the upper outer portion so they could hold some old twisted electrical wiring as a hanger for the piece.

WATCHFUL EYES

As I'm re-reading this, I am reminded that I should let you know that all of these elements were gathered here and there, and everywhere in between, over the course of years—not at all something that I went out and picked up specifically for this piece. In the case of the vintage goggles, when I unwrapped them from my trip to Arizona, I immediately draped them onto my chandelier in my studio so I could enjoy them every day. I loved the way the light spun through them with other treasures that have found a home dangling from above. But then came the day when I envisioned them on this assemblage, and down they came to weave their way into this story.

PREVENTING PEELING

When using these old gesso frames, they tend to peel and flake off a little, or a lot. Giving them a thin layer of spray matte sealer helps "glue" some of those loose pieces in place. After one spray, let completely dry and, if needed, add a second coat for safe measure. Always work in a well-ventilated area when using the sealer.

PERSONAL PROMPTS

How may I nurture my creative spirit this week?

How can I carve out some time for myself in my creative space?

When I give myself this gift, how does it make me feel?

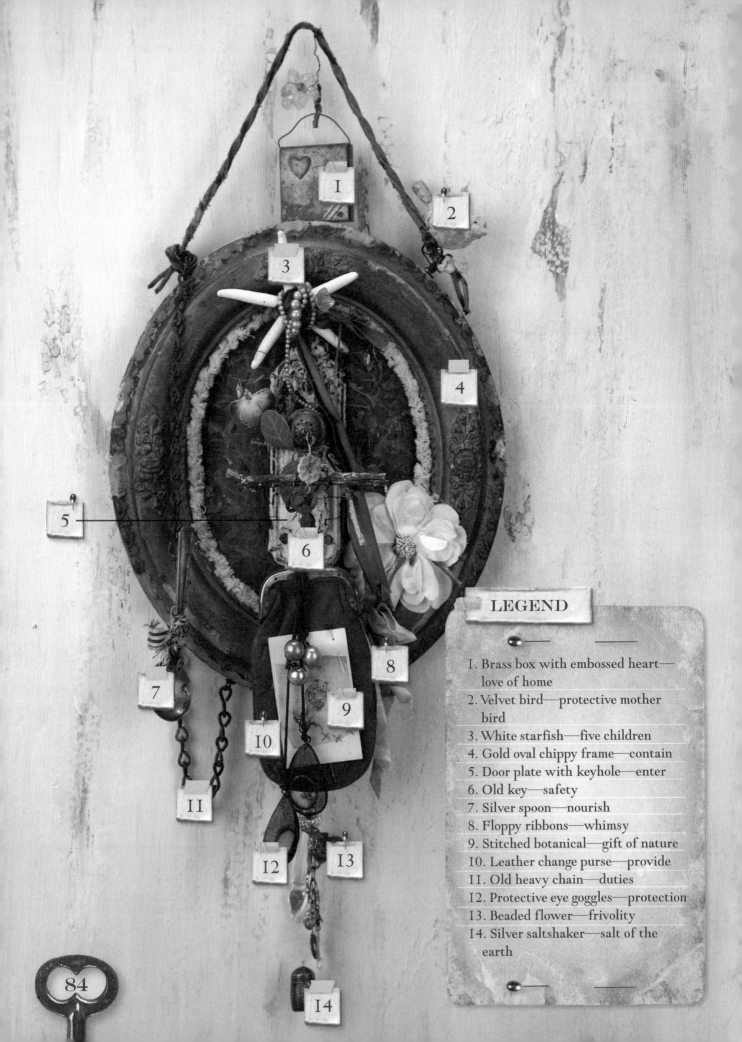

LEGEND

1. Brass box with embossed heart— love of home
2. Velvet bird—protective mother bird
3. White starfish—five children
4. Gold oval chippy frame—contain
5. Door plate with keyhole—enter
6. Old key—safety
7. Silver spoon—nourish
8. Floppy ribbons—whimsy
9. Stitched botanical—gift of nature
10. Leather change purse—provide
11. Old heavy chain—duties
12. Protective eye goggles—protection
13. Beaded flower—frivolity
14. Silver saltshaker—salt of the earth

84

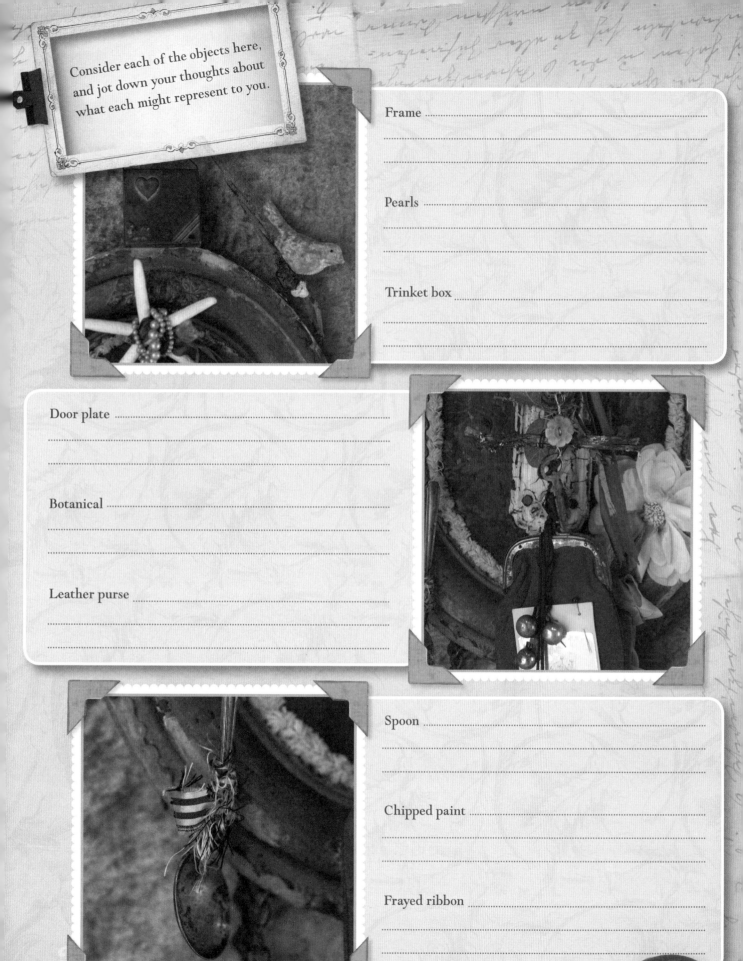

Consider each of the objects here, and jot down your thoughts about what each might represent to you.

Frame ..
..
..
..

Pearls ..
..
..
..

Trinket box ..
..
..
..

Door plate ..
..
..
..

Botanical ..
..
..

Leather purse ..
..
..

Spoon ..
..
..
..

Chipped paint ..
..
..

Frayed ribbon ..
..
..

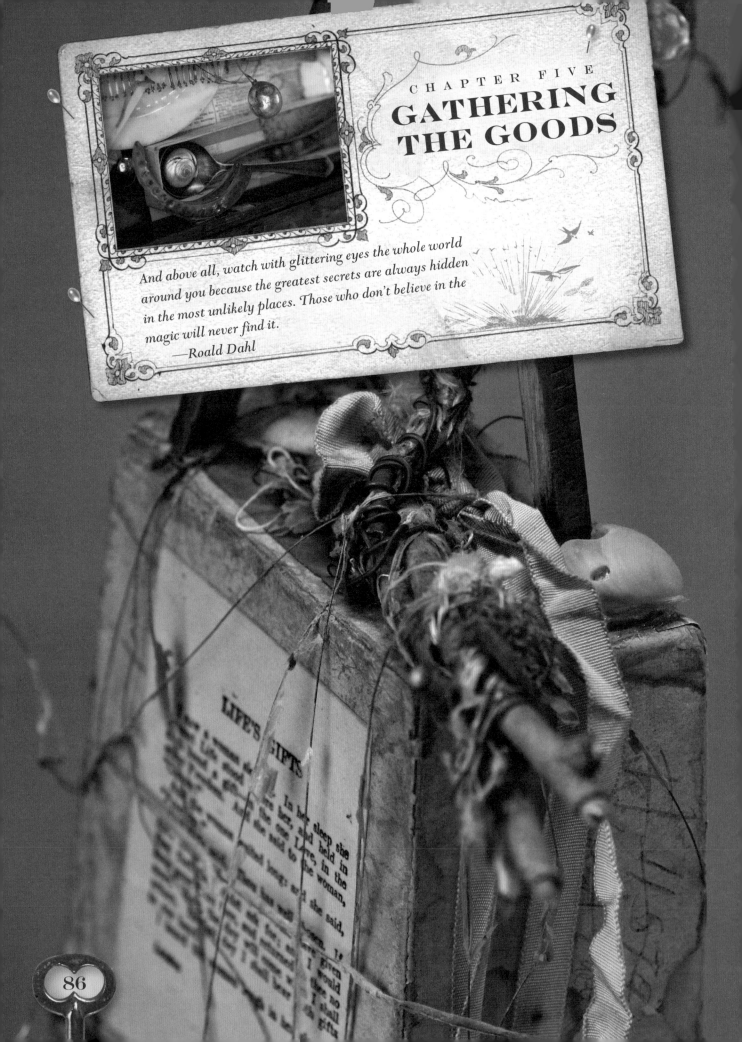

CHAPTER FIVE

GATHERING
THE GOODS

And above all, watch with glittering eyes the whole world around you because the greatest secrets are always hidden in the most unlikely places. Those who don't believe in the magic will never find it.
 —Roald Dahl

LIFE'S GIFTS

I have long been a collector of stuff, like I'm sure so many of you are. There is just something about these old things . . . they tug at my imagination—they always have and I'm sure they always will. The things that are family treasures that are gifted and collected are the best of the best. These family collections usually aren't fancy at all, but are priceless, tangible memories of loved ones that have rich stories attached and hidden safely within.

Most of the time these "goods" that I use as my inanimate words are something close to what I remember, or something that evokes a memory or story, and not the actual hand-me-down. These "seconds" will do for the sake of creating a memory assemblage, and at times, it's better than using the original item for the sake of value. At other times I'm drawn to items that I have no earthly idea what I will use them for. If an object speaks to me, and I can afford it, it comes home with me and will sit happily amongst other "finds" that have not found a home yet within an assemblage, and that's OK because I enjoy what these "words" offer as yet another still life on my studio shelf or table. I do have to edit from time to time, rotating things around. This is a huge help to me with knowing what's in stock—and inventory control!

I'd have to say that I always score my best finds when I'm not even on the prowl for anything in particular. Then, out of the blue, and off the beaten path, there's a little sign for a porch sale, and there she sits, a little ma-and-pa shop brimming with ever-so-perfectly priced everything. You've come upon places like this, too, I feel sure—spontaneous junking at its very best.

I'll have to admit, though, that I'm saddened at times, knowing that my gains come along with a bruised heart. I try to look at it like I'm there to rescue those items that day, and I imagine them thanking me! I'm a junk lifesaver, always looking for a chance to toss a life preserver into the waters of what memories are made of, reeling the castaways into the safety net of my boat. "Sentimental fool" some would call me, and to that I'd have to say, "I'm honored."

I know I'm not alone here when I say that the act of stumbling across a meant-to-be-treasure gives me a rush. You know this collection of "stuff" is a something that speaks to so many. When I moved to the Midwest from Texas, I seriously thought I had died and gone to junkin' heaven! The prices were ridiculously low, and the abundance of goods was truly at every turn! It's a little bit different now, some fifteen years or so later, but I don't let that detour me at all.

I feel I must interject here that just because I use vintage items and junk as my objects of choice for my assemblages doesn't mean that there aren't many other materials that are going to be your choices for your work. I've seen and experimented with a lot of other items that give a totally different look and feel to a piece. This is what is going to set your work apart.

Transformation is a big part of what this book is about—hopefully in more ways than one! When taking a found or collected object from its original use, and then transforming it into another life form—morphing it, so to speak—embracing the hidden messages in these inanimate objects, giving them a new purpose and a second life. This ongoing gathering of your messages and the shape-shifting of your finds will become an exploration that will spin your story in new and matchless ways. For now, begin by shifting your focus (shift happens!) from the obvious, and open up to see with new eyes these found objects that you've been holding onto—and those that have yet to cross your radar. Something wonderful is in their near future!

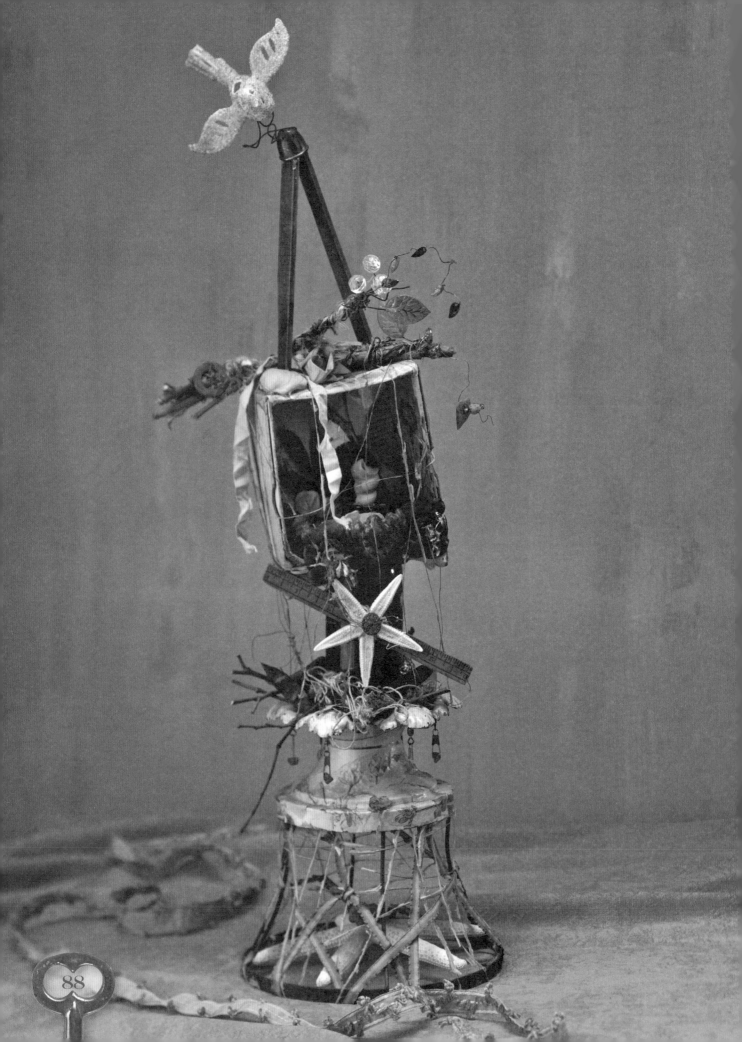

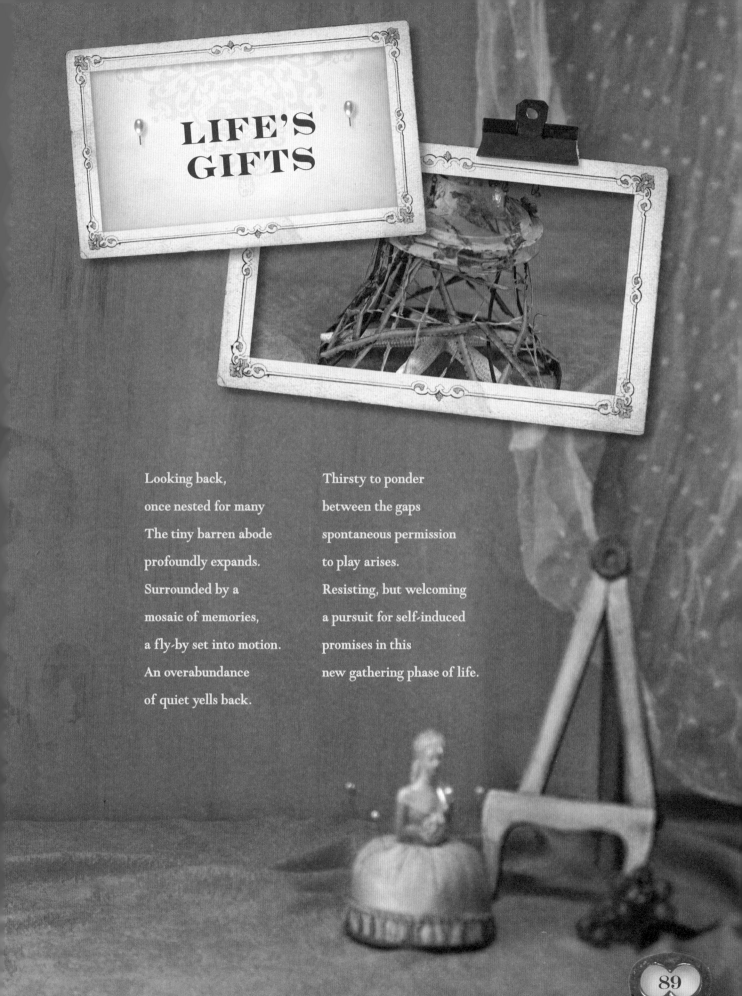

LIFE'S GIFTS

Looking back,
once nested for many
The tiny barren abode
profoundly expands.
Surrounded by a
mosaic of memories,
a fly-by set into motion.
An overabundance
of quiet yells back.

Thirsty to ponder
between the gaps
spontaneous permission
to play arises.
Resisting, but welcoming
a pursuit for self-induced
promises in this
new gathering phase of life.

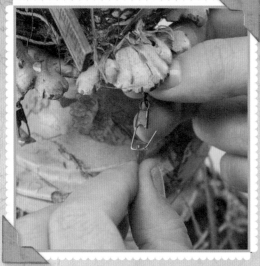

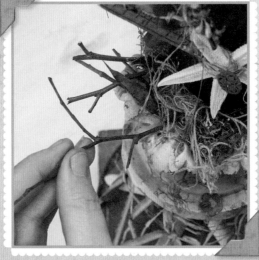

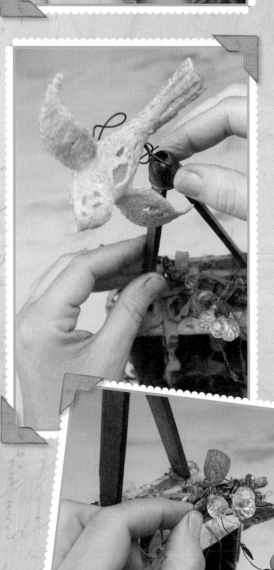

This piece has gotten a few facelifts over the past several years. I learned a lot about what works and what doesn't, but, at the same time, those things that I thought didn't work too well turned out to be an asset in many ways.

The birth of this piece began with thoughts of the dioramas I loved in elementary school. The box was the beginning here. I collaged and embellished the inside first. Knowing that I wanted to use something different than another spring, I decided on an old brown bottle. This is where the not-so-good part of this one began. I made a hole in the bottom of the box and pushed the lip of the bottle through, but since the lip was larger than the neck, I had created a wobbly situation. I secured the bottle the best I could from the inside with cloth first-aid tape, then tried to camouflage that boo-boo. It worked for a while, until the upper elements were added, creating a top-heavy effect for the old dilapidated box.

I began wrapping wire up and around and down through the scalloped edging of the collaged metal lamp base, and this held things up slightly straight. I actually loved the additional depth and framing that this gave to the piece. It also allowed me to use the wire as another way to dangle other "smalls" from it. I tucked in sticks, moss and seed pods to create a nest effect around the bottom of the brown bottle, securing things a little with hot glue, and then added the small wooden ruler and the starfish that was later adorned with a filigreed ancient metal button at her center.

Small brass fishing swivels, that I added amber nuggets to, were hooked into the decorative openings on the metal fixture, creating a sweet little dangle effect.

LIFE'S GIFTS

In keeping with the haphazard wiring going on at the top of this piece, I continued the same effect around the open bones of the rusted shade, along with some new narrow variegated green ribbon. The starfish on the bottom was carefully glued, at the tips, to the lamp base. I added amber-colored flower beads to tie in with the amber nuggets used with the swivels.

The crowning part of the box, as I mentioned, was a necessary trouble-maker. It wouldn't have looked right with anything less. Adding the wrapped and wired twigs with scrunched and tea-stained green grosgrain ribbon and torn and frayed fabrics gave me the texture I was looking for, along with an added rusty washer and brass leaves. The peak of the house is another wooden ruler topped with the lid of an antique silver saltshaker, to which I was able to wire the bird to complete the story. Originally, this sat on top of a glass butter dish base that had lost its domed cover. Sadly, that was broken, and I now have her sitting on a small crystal pedestal cake plate that reminds me of one my grandma used to have.

GOOD BONES

Always determine the sturdiness of your elements—in this case the box. It was the right color and size but lacked the stableness I needed. It continued to be an issue, always forcing me to find ways to shore it up. Begin with good, sturdy "bones." It will save you countless hours!

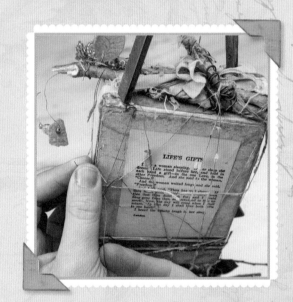

PERSONAL PROMPTS

WHAT ARE SOME WAYS THAT CAN HELP ME TO BE MORE PLAYFUL WHEN I'M CREATING?

HOW MAY I BE LESS CRITICAL OF MY WORK?

HOW CAN I FIND THE TIME I NEED TO CREATE?

LEGEND

1. Bird—soar
2. Wooden ruler—rooftop
3. Embellished twig—gifts from nature
4. Spiral shell—traveling
5. An old box—the home
6. Starfish—family
7. Small ruler—record of time
8. Nest—security
9. Fishing swivels—quiet time
10. Amber nuggets—sunshine
11. Woven lampshade—crossing paths

Consider each of the objects here, and jot down your thoughts about what each might represent to you.

LIFE'S GIFTS

String

...

...

Cardboard box

...

...

Book page

...

...

Cracks

...

...

...

Spiral shell

...

...

Fine wire

...

...

Lampshade

...

...

Amber nuggets

...

...

Starfish

...

...

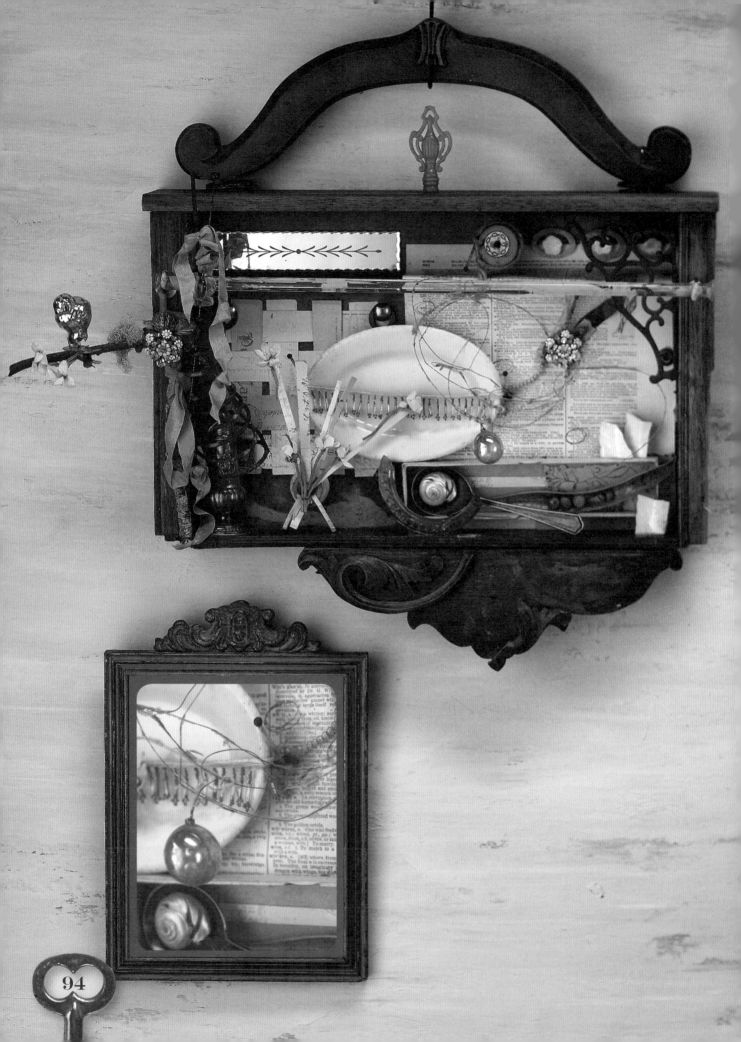

94

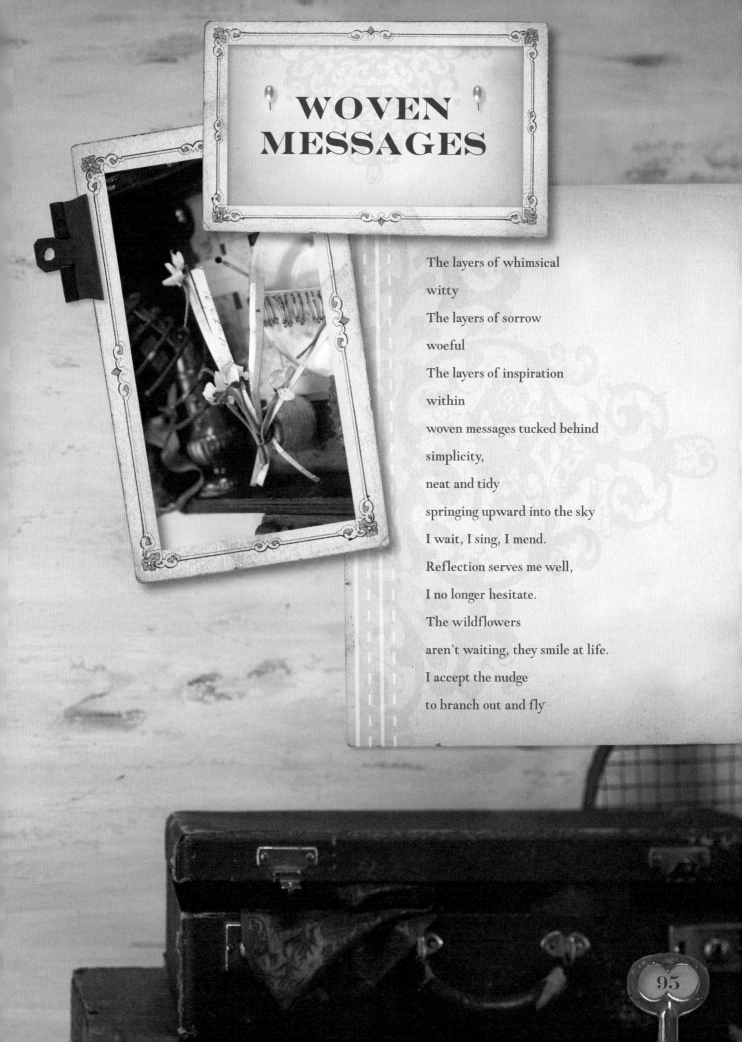

WOVEN MESSAGES

The layers of whimsical

witty

The layers of sorrow

woeful

The layers of inspiration

within

woven messages tucked behind

simplicity,

neat and tidy

springing upward into the sky

I wait, I sing, I mend.

Reflection serves me well,

I no longer hesitate.

The wildflowers

aren't waiting, they smile at life.

I accept the nudge

to branch out and fly

WOVEN MESSAGES

Creating this piece was what I would call more of an experiment than most other works in this book. I wanted to see if I could choose the elements in a random fashion, fairly quickly, and then create the story, instead of the other way around, like I typically work. I have to admit, this was a little bit of a challenge and backwards for me. But I always appreciate a collected "find" that presents itself in the matchless moment as the foundation for a new tale to tell. I really like to think of this creative process as a dance—sometimes the symbolic "words" lead me out onto the dance floor, and sometimes I make the first move! Whatever the journey, it's trusting that rhythm of the music that entices our creative souls.

Knowing that the small oak drawer was going to be the bones, I had given myself a ten-minute time limit to go into my studio and gather elements that spoke to me—either with color, texture, repetition or, of course, and most importantly, symbolism. Once I had gathered all the finds into the drawer, I took it all out of my studio, knowing that if I had tried to work on it inside my studio, I'd be too distracted by "what could be." Spreading everything out first, I then began layering and playing with the potential of these random items that I had been drawn to.

The drawer was always going to serve as the haven, but, also knowing that I would reach outside of her four safe walls, this piece would speak of exploring the beauty of the outside world. The dictionary page was chosen by chance, without any regard to the words. Turns out, my eyes were immediately fixed on three crowning words and their meanings that set the tone for the rest of this piece—witty, woeful and within. Each trait encompassed a wide range of ideas for me to play around with.

COLLECTING DUST?

A great way to clean most pieces of your artwork, is with a duster. If there are places a duster won't reach, I use the canned air that is made for computer keyboards. Just don't get too close— this stuff is powerful. I also use a Q-tip dipped into hot water to get into some tight spots.

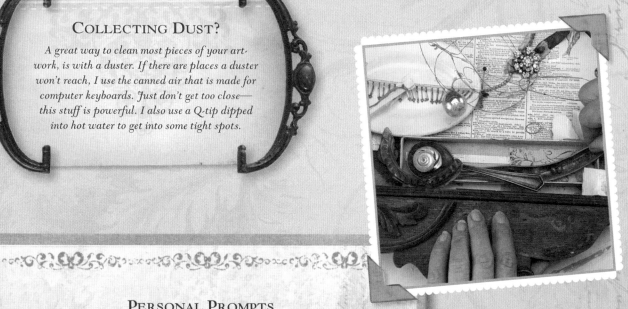

PERSONAL PROMPTS

I CAN BE GENTLE WITH MYSELF BY

I WILL EMBRACE MY DISCOVERIES BY

DAILY DISCOVERIES PROVIDE SUBSTANCE TO MY WORK BECAUSE

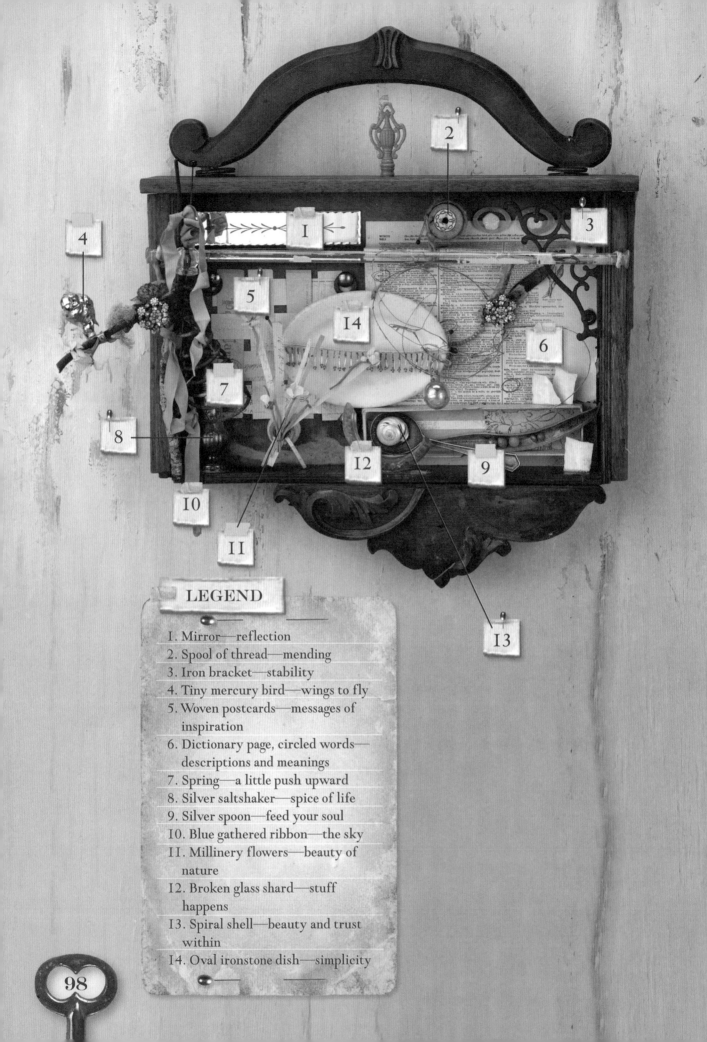

LEGEND

1. Mirror—reflection
2. Spool of thread—mending
3. Iron bracket—stability
4. Tiny mercury bird—wings to fly
5. Woven postcards—messages of inspiration
6. Dictionary page, circled words—descriptions and meanings
7. Spring—a little push upward
8. Silver saltshaker—spice of life
9. Silver spoon—feed your soul
10. Blue gathered ribbon—the sky
11. Millinery flowers—beauty of nature
12. Broken glass shard—stuff happens
13. Spiral shell—beauty and trust within
14. Oval ironstone dish—simplicity

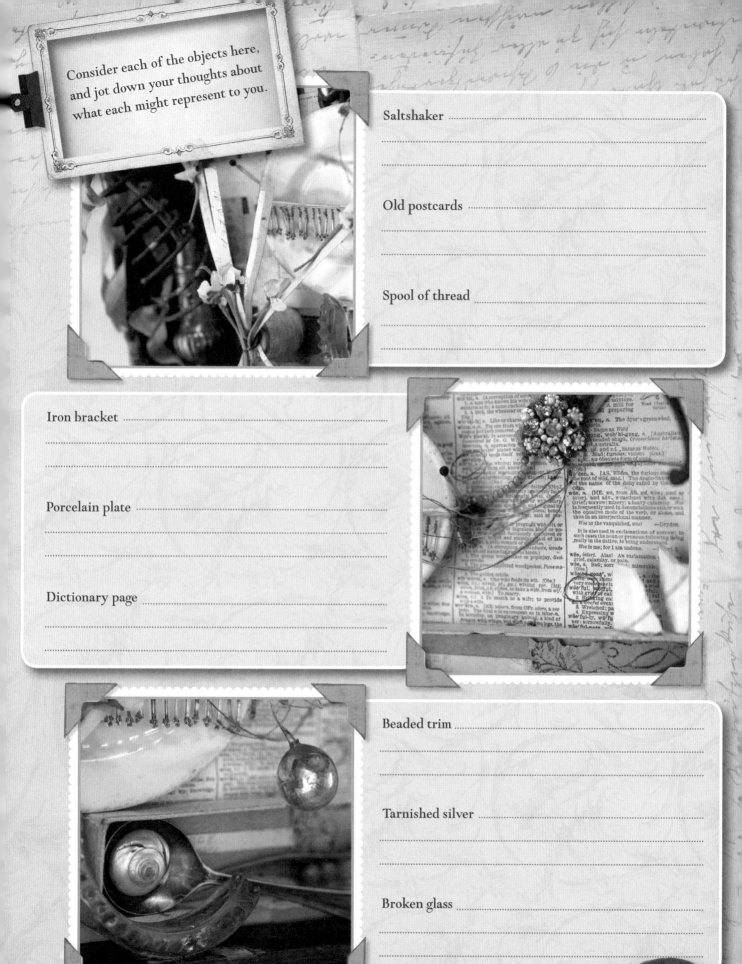

Consider each of the objects here, and jot down your thoughts about what each might represent to you.

Saltshaker ..
..
..

Old postcards ..
..
..

Spool of thread ...
..
..

Iron bracket ...
..
..

Porcelain plate ...
..
..

Dictionary page ...
..
..

Beaded trim ...
..
..

Tarnished silver ..
..
..

Broken glass ..
..
..

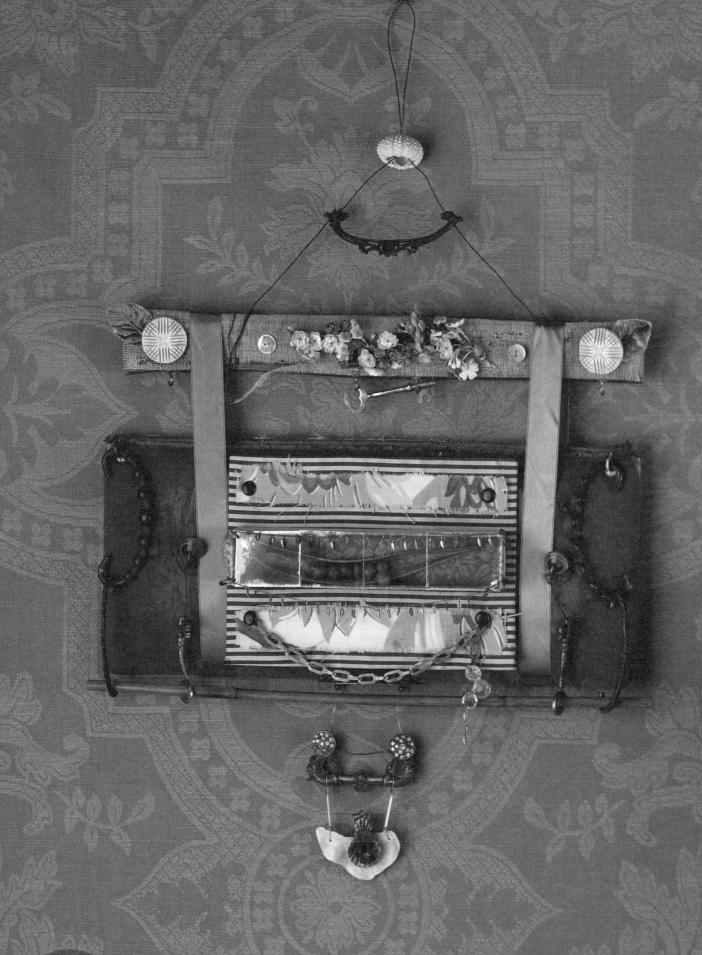

LIFE
BALANCED

Challenged, definitely!

This beam of balance

In and out of the pod

One falls out, quick

Get him back in

Safety rules, love rules

Rules rule

Home is anything but

Balanced

Memories are home

Life stories contain

the delicate love

Hold it in place

In all four corners

Handle it with humor

Unlock the greater vision

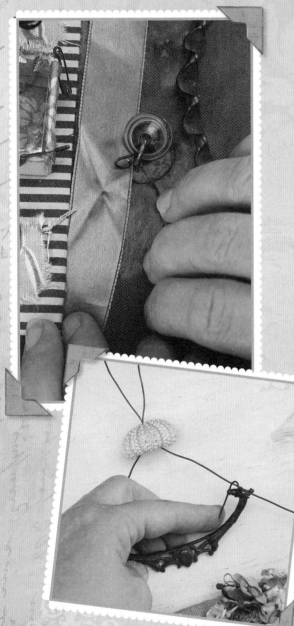

I'd be lying if I didn't say this one gave me fits from the very start. The only thing I knew for sure from the beginning was the fact that I loved the vintage tattered book spine. I turned it to show the inside, where the worn creamy-colored mesh shows; I just loved its texture. From there I went on to add the length of millinery flowers and leaves, knowing that they would fit nicely in the center. I think the symmetrical design of this one is what threw me, because I am anything but balanced! It was a challenge to stay on course with it, but I went along.

The gold velvet base is another a vintage Victorian photo album cover. These albums often have a hard inner piece that makes them fairly easy to attach things to. Here, I covered a piece of cardboard with silk cream-and-black-striped fabric to make a center statement. This gave me another base to build upon. I frayed the vintage bark-cloth floral fabric by tearing it along the edges. It added some extra colors that I thought would be fun to work with, and at the same time, a funky twist to the Victorian-ness of the piece.

The little storybox began by lining the long narrow jewelry box with the sheerest brown-and-cream floral ribbon; then I added the seed pod and pearls that represented "seeds." This continued to help the flow of the design. I added a tiny brass necklace that had the littlest leaves dangling from it, all around the outer edges of the box. I did this after I glued misshapen mica sheets to the box to help frame the entire vignette. Take note here that these less-than-perfect elements only add to the vintage history. Things age over time, and this is one of the elements in my work that I really love to convey.

LIFE BALANCED

Old chains and skeleton keys were added here and there to hang things from, adding more great textures. The apple-green satin ribbon was an afterthought. I was going to use wire, but really loved the girlie twist it added. Vintage carved buttons, and two tiny mother-of-pearl buttons embellish the spine for added depth and color. I love to use old brass drawer handles—they add a bit of whimsy because they remind me of those plastic Barrel of Monkeys that hook onto one another. A bamboo rod, thread through two of those keys, gave the handle a place to hang. Below the handle, I wired the two rhinestone buttons onto another handle, creating a little place to dangle a sweet heart-shaped shell that I adorned with a vintage candle clip. It all adds up to a lot of layers that seem right at home.

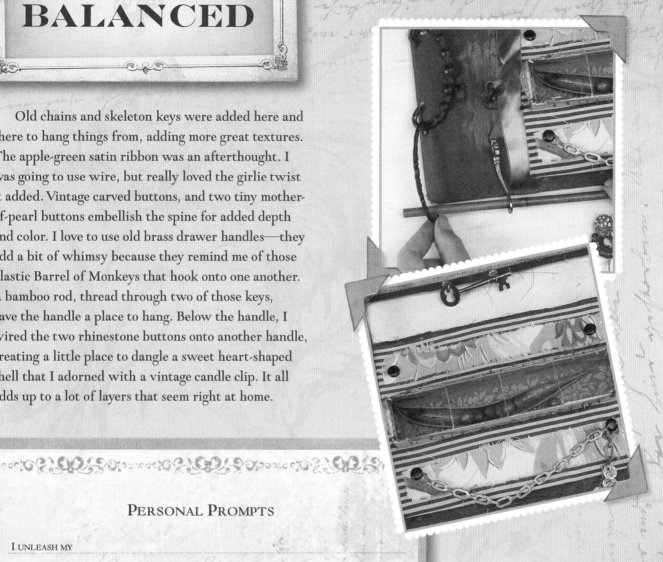

PERSONAL PROMPTS

I UNLEASH MY

THESE ARE MY VISIONS FOR A CREATIVE LIFE

WHEN I INCORPORATE AUTHENTIC PASSAGES IN MY ARTWORK, I FEEL

PERFECTLY PRACTICAL

Sometimes your pieces can serve a practical function. I made this one with the thought of it serving as a jewelry keeper. It looks wonderful with necklaces dripping from the bamboo, and earrings secured to the gold velvet. Adding function to the piece is just another way to get your mind wrapped around all the possibilities out there!

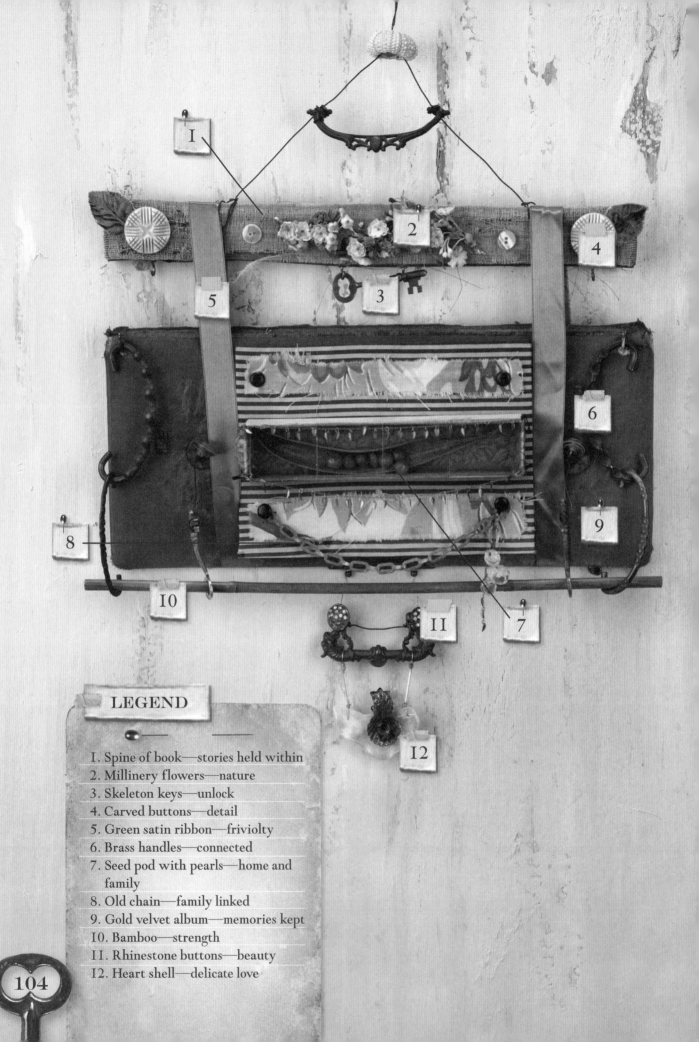

LEGEND

1. Spine of book—stories held within
2. Millinery flowers—nature
3. Skeleton keys—unlock
4. Carved buttons—detail
5. Green satin ribbon—friviolty
6. Brass handles—connected
7. Seed pod with pearls—home and family
8. Old chain—family linked
9. Gold velvet album—memories kept
10. Bamboo—strength
11. Rhinestone buttons—beauty
12. Heart shell—delicate love

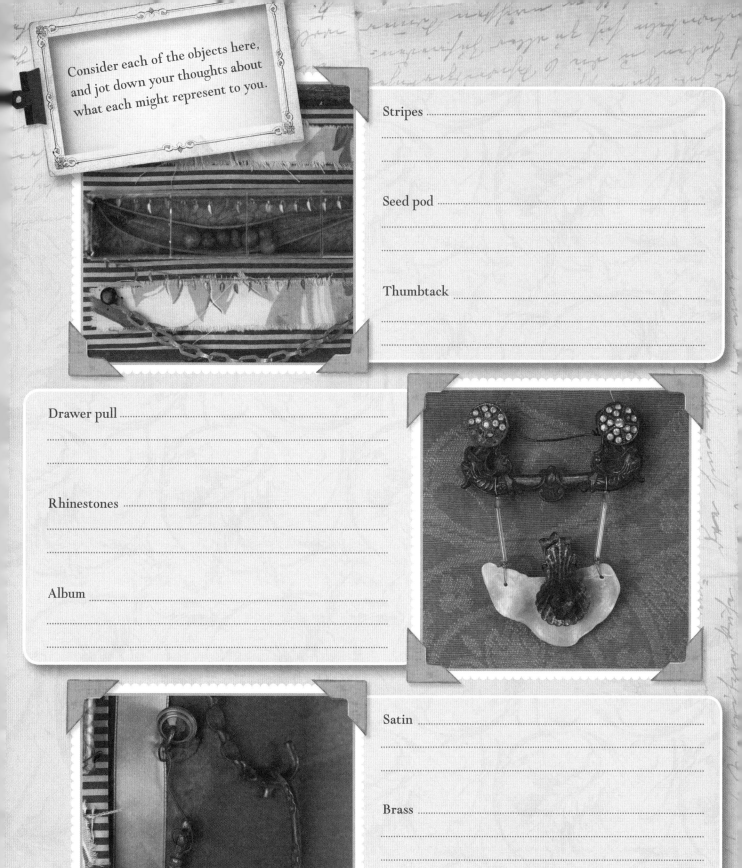

Consider each of the objects here, and jot down your thoughts about what each might represent to you.

Stripes ..
..
..

Seed pod ..
..
..

Thumbtack ..
..
..

Drawer pull ..
..
..

Rhinestones ..
..
..

Album ..
..
..

Satin ..
..
..

Brass ..
..
..

Bamboo ..
..
..

KEEPING IT TOGETHER
(TIPS & TECHNIQUES)

ATTACHMENTS

If I could have my way right about now, I'd leave the back door to my studio wide open, invite you to come on in, pull up a comfy chair, and we'd explore this funky "assembly-required" art form together. I've found that a hands-on, get-messy, explore-all-the-possibilities-together approach is truly what works the very best. It's a trial-and-error mindset that makes the best teacher.

I don't have all the answers, by any means, in this artistic arena—just stuff from this old heart of mine that just happens to work for me and may work for you, too. I'm always happy to share whatever I've learned along the way. So let's get started!

Everything that I do to create interest in a piece, I do by adding textures, aging and tons of layers. Most of the time, I rely on my timeworn and funky finds to speak for themselves, but occasionally I have to doll them up (or should I say down?) and help them along in the aging process. I am one who likes to keep things very simple with minimal techniques that would otherwise tie me down. I've often thought of my process as if I were living way out in the country without any outside influences (not too far from reality!), asking myself, "How can I assemble this with what I have, how can I do this differently, and how can I make this as simple a process as possible?" I've always been drawn to old tramp art and primitive arts for this very reason. It's that industrious, use-what-you-have mentality that strikes a creative cord with me, and makes me challenged and happy!

WIRE

As you may or may not have already noticed, wire is my best friend! I'd be safe to say that, it's the most versatile product that I use. It's very forgiving and makes it so easy to add countless layers. I don't have to be very precise with it, and I like the pure happenstance way it ties everything together. Get yourself a little stockpile of assorted varieties and sizes, and then you're good to go.

★ SECURING TWO LARGER OBJECTS TOGETHER

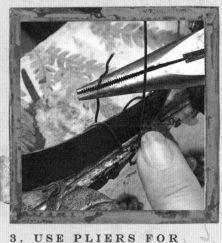

1. PREPARE FOR A HOLE

To wire two objects together, sometimes it's necessary to drill a hole in one or both objects. Here, I want to drill a hole into this metal box, but before I actually drill, I make a small dent in the metal, using a hammer and a nail. This will keep the drill from "walking."

2. DRILL THE HOLE

Now it's a snap to drill the hole. Just place the drill bit in the indention and drill.

3. USE PLIERS FOR STIFF WIRE

I like to work with a piece of wire that is not only long enough to twist several times but will be also be available for me to attach elements to later if I want. Here, I've threaded the wire through the two holes that I drilled into the side and the top of the metal box. I then brought it up and around to attach it to the brass "crown." Be sure to use pliers to work with the wire—it will save your fingers!

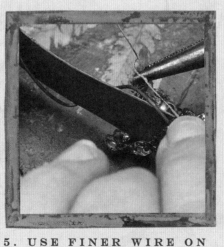

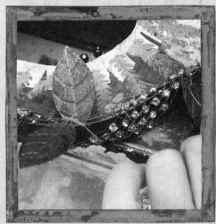

4. TWIST TO SECURE

Hold pieces in place as you twist the wires together, creating a secure hold.

5. USE FINER WIRE ON SMALL ELEMENTS

Finer-gauge wire can be used to secure smaller items that just need to be tacked in place but don't need to be overly stable. Basic wire wrapping, such as a rosary wrap, can be applied here.

6. SECURE WITH TIGHT WRAP

With the excess wire, continue wrapping around the piece to add texture and to save a place to add other elements later. At the end of the piece of wire, secure it in whatever way feels secure enough to you.

✦ TYING ON SMALLER ELEMENTS

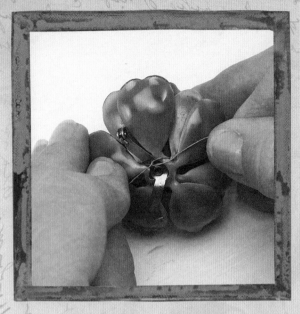

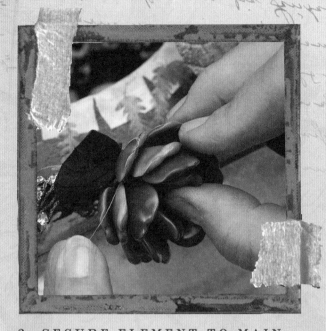

1. ADD WIRE TO ELEMENT

You can add an element such as an antique brooch by first adding wire to the back of it.

2. SECURE ELEMENT TO MAIN PIECE

Then secure the wire on the brooch to the main piece by wrapping the wire around wherever it makes sense.

✦ CREATING A GARLAND OF ELEMENTS

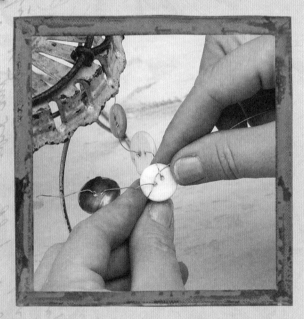

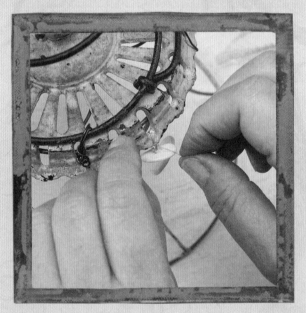

1. STRING EMBELLISHMENTS ONTO WIRE

Fine wire can be used to make a sort of garland to hang small elements such as buttons around a piece.

2. SECURE GARLAND TO MAIN PIECE

Secure the garland to the main piece in however many places you feel are appropriate.

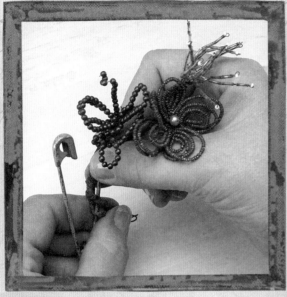

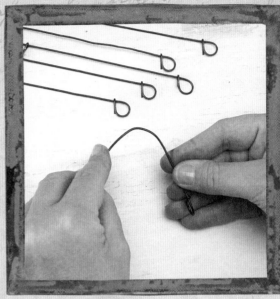

MAKE USE OF EXISTING WIRE

Many elements come with their own wire so you can attach them to something all on their own—no additional wire needed.

1. BEND FENCING TIE IN HALF

Wire is great for creating your own hangers. These fencing ties (found in your local lumber yard's fencing department) are great. Simply bend one in half, or wire several together and add embellishments in between, for a longer hanger. Sometimes these are known as rebar wire ties and are found in the masonry department.

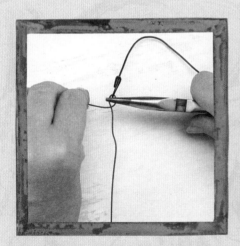

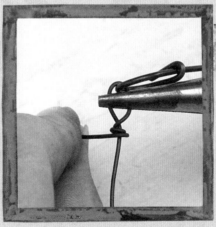

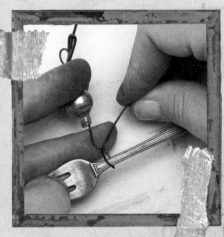

2. LINK ON A SECOND WIRE

A rosary wrap can be used to add a second, vertical wire that will attach to a horizontal object or dowel. Start with a loop at one end of a small length of wire and link it through the loop on one end of the tie.

3. WRAP AROUND LOOP

Wrap the wire several times around the base to secure it.

4. SECURE TO ELEMENT

String on beads or other decorative elements at the same time if you like, then you can attach it to a horizontal element, wrapping the wire around it a couple of times.

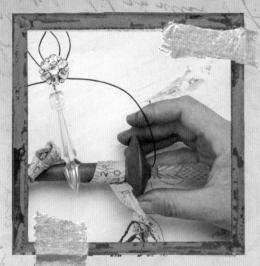

5. VARIATION, DECORATIVE

You can be as decorative as you like, such as the hanger I made here for this mobile.

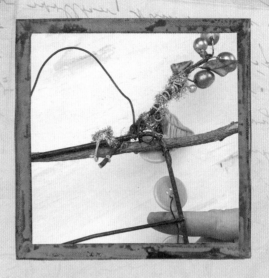

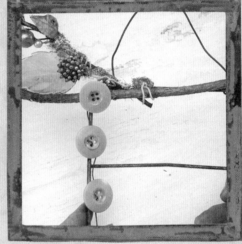

6. VARIATION, SIMPLE

Wire can also be extremely simple for a hanger.

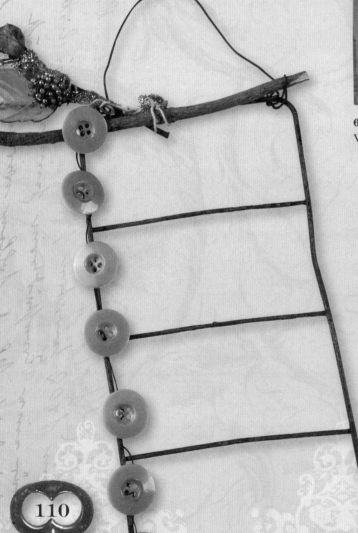

TACKS AND NAILS

These are another must-have for your stash. I use these for securing so many things that aren't heavy enough for a regular nail. I also like the variety of finishes these come in. I personally don't use the shiny, brand-spanking-new ones very often. I prefer the tiny black upholstery nails with a flat head, but I use them all. I find most everything I need at the local discount store or hardware store.

 ## UPHOLSTERY NAILS

HAMMER IN NAILS
These nails can be hammered into wood substrates to hold a number of different things, from fabric to trim to small embellishments.

 ## THUMBTACKS

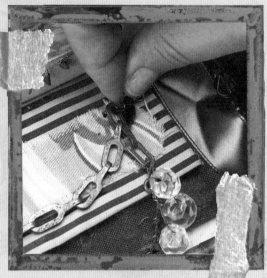

PUSH IN TACKS
Thumbtacks can hold whatever you like, too. Here, I have used one to secure an old piece of chain that I will add things to later.

HOOKS

I got turned onto cup hooks when I stumbled across a huge box of them at a flea market. They were perfectly aged with peely paint and a fabulous dingy tinge. Sadly, I am just about down to the bottom of that box. I hate it when that happens—a fabulous find comes to an end. What will I do? I'll do my best to wing it with new ones made to look old. I toss shiny new brass ones into some acetone to take off the shine, then use salt and vinegar to soak them for several days. Check out the Internet for more ways to age brass. I found some useful recipes online for all kinds of aging techniques.

SCREW IN CUP HOOK
Cup hooks are wonderful to add to pieces of wood because you can hang things off of them later.

 111

ADHESIVES

There will be times that a little dab of strong glue will do you just fine. I have experimented with a lot of glues and adhesives over the years, and have learned a lot about which ones I prefer and which ones I don't. I have found the best ones to be those that are clear. With that said, my favorites are Liquid Nails (clear), E-6000, Krazy Glue (gel) for small elements, and clear caulking/silicone. The ones you use will be determined by your projects. The heavy, thick ones are usually reserved for heavier elements, and the lighter ones for tinier elements. Be sure to check each manufacturer's instructions for detailed information.

★ LIQUID NAILS

 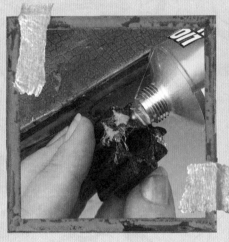 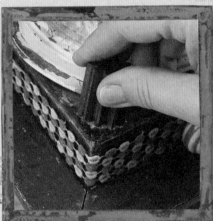

1. APPLY ADHESIVE TO SURFACE
Liquid Nails (I prefer clear) is used on items that are heavy, such as these pieces of gears. Put a little adhesive on the receiving surface to start, then let set up for a minute or so.

2. APPLY ADHESIVE TO ELEMENT
Next, put a little adhesive onto the element you wish to adhere. Let the adhesive set up for a minute or so. This gives it some tooth and will make the glue hold better.

3. ATTACH TOGETHER
Then attach the two surfaces together, applying a little bit of pressure until it "grabs."

★ E-6000

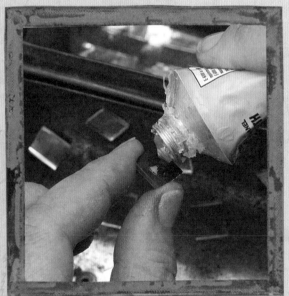

1. APPLY ADHESIVE TO ELEMENT
E-6000 can be used for adding lighter-weight items such as these pieces of mirror.

2. STICK ONTO RECEIVING SURFACE
Tape can be used to hold items in place while the glue cures, if gravity is an issue. I like to use blue painter's tape; it just seems to lift off the easiest.

★ KRAZY GLUE

WORK WITH ADHESIVE QUICKLY

Superglue is good when you need something to cure quickly because you have a lot to do or you don't want to disturb what you did as you're working in a different area.

★ TAPE

SECURE LIGHTWEIGHT ELEMENTS

Little pieces of tape can be used to hold down flat items like ephemera, and as a textural element at the same time. I like to use torn masking tape and cloth medical tape that I've aged with watered-down paint or walnut ink.

HAND-SEWING

There's something about hand-stitching that really adds a nice touch; it also feels old for some reason.

STITCH WITH NEEDLE AND THREAD

Simple hand-stitching is a great way to attach two things together, and a nice way to put your mark on a project.

MINIATURE STORY ELEMENTS

Little boxes have always found a home in my assemblages. I think one reason is that they are like tiny shrines or little fairy boxes with sweet stories waiting to be told. I collect and keep lids and boxes of all sizes, really, but I prefer small ones that I can add to a larger assemblage. Sometimes they are just a trinket in and of themselves. Whenever possible, after all the inside matters are taken care of, I top these little shrines with a sheet of mica. Mica has a magical twist all its very own, softening everything in its path with a faded tea-stained glow, giving it that delightful aged appeal.

MICA STORY BOX

1. FILL SMALL BOX WITH OBJECTS
You can build a little still life in a box or shallow dish, then use a piece of mica over it as a picture window and to hold everything inside. Trim the mica to the size you want and then attach it to the box using small pieces of tape.

2. WRAP WITH WIRE
The mica can also be secured with a wrap or two of wire or string.

DANGLES

OK, dangles, for lack of a better term, describes those combined, smaller elements that add lingering layers and added interest to your work. I use them in every piece that I create in some form or fashion. It's not that more is more, but for me it helps to create the story with more symbols. They are usually haphazardly concocted with ribbons, torn fabric swatches, twine or waxed linen, then scrunched and bundled in a free-form way. It's hard to describe exactly how I go about making these—I just try not to make it look too planned or thought out, if that makes any sense! Take a look at the photos for a better understanding of this "dangle" process. When I add elements to these dangles, I usually try to incorporate the use of color, repetition and/or textures.

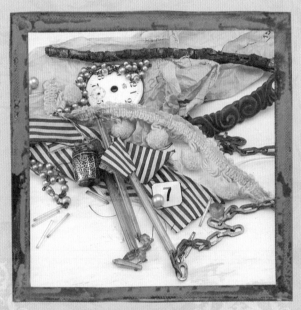

1. DECIDE ON ELEMENTS
Gather materials that you'd like to use to create your dangle.

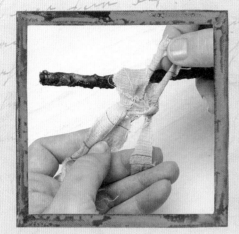

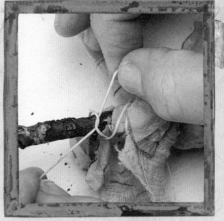

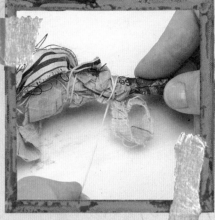

2. BEGIN WITH A TIE OF FABRIC

Tie a frayed piece of fabric to a stick, or to a link in a chain, or anywhere you wish to begin.

3. SECURE ADDITIONAL SCRAPS

Add additional texture with some patterned tissue or other scraps of fabric and secure them with waxed linen.

4. WRAP RANDOMLY WITH WAXED LINEN

Continue wrapping the linen around randomly.

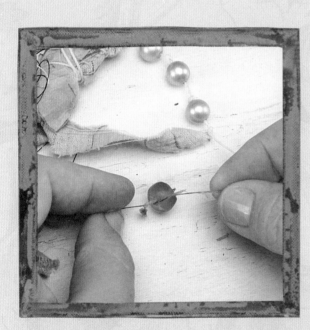

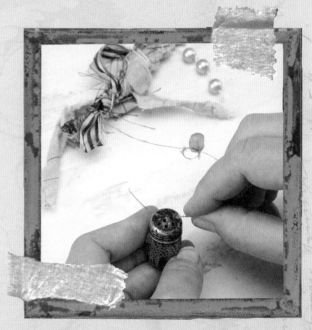

5. TRY SOME WIRE

You can switch to wire if you like, to add other elements such as the beads I'm adding here. Wire can be tied just like the linen.

6. THREAD ON OBJECTS

Continue adding items, such as this miniature saltshaker that I threaded onto the wire.

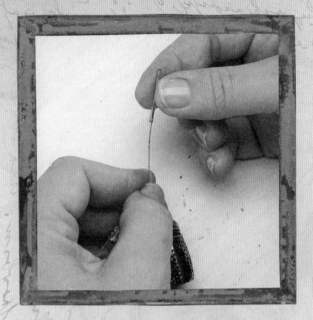

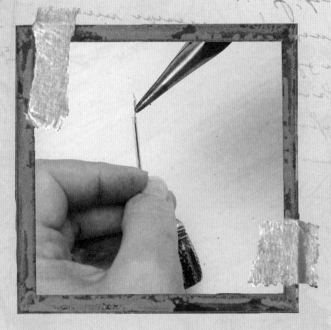

7. ADD A BEAD

One way to secure an object is with a bead. Thread a bead onto the wire, after the object.

8. COIL THE WIRE

Then, finish it off by making a coil at the end of the wire, so the bead is held securely.

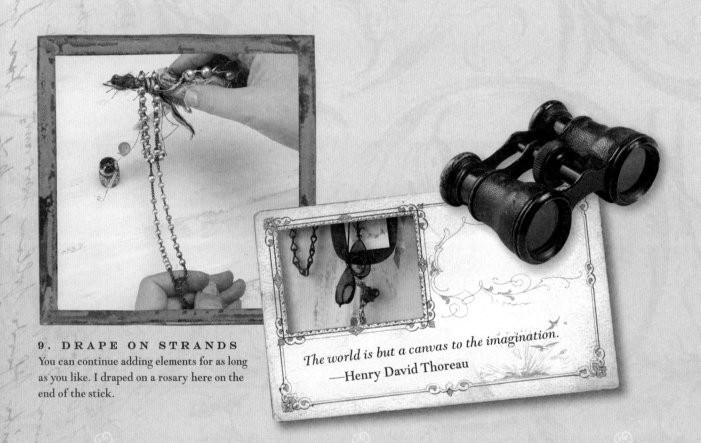

9. DRAPE ON STRANDS

You can continue adding elements for as long as you like. I draped on a rosary here on the end of the stick.

The world is but a canvas to the imagination.
—Henry David Thoreau

CASTING NEW ELEMENTS

This is a good technique if you have something that you just have one of and would like to duplicate it for multiple projects—as is the case here with this bird pin that I just couldn't pass up on one of my off-the-beaten-path trips. I wanted to use it in one of my artworks, but I also wanted to be able to reproduce it. This process takes a couple of days, but once it's completed, you will be able to make countless pieces from this one mold. Let me just say here that although there is a way to create a three-dimensional mold, which I have never attempted, this one is for those items that are flat on the backside.

1. LAY DOWN WAX
Working on a flat surface, wax over an area to make it nonstick. I used a piece of masonite here.

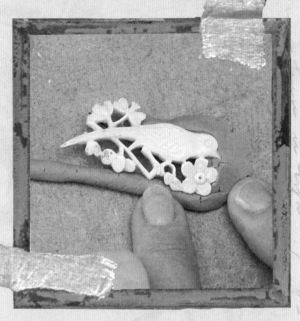

2. LEVEL OBJECT WITH CLAY
Set a pin or other piece you want to cast on the surface and work "snakes" out of oil-based modeling clay around it to make it level. Work the clay carefully into the crevices.

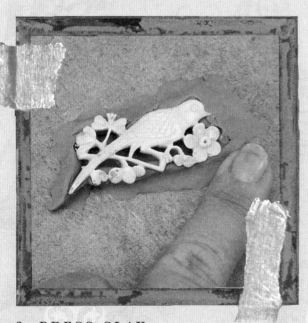

3. PRESS CLAY
Pinch the clay down around the edges.

4. BRUSH WITH WAX
Brush a thin coat of melted paraffin wax over the entire piece.

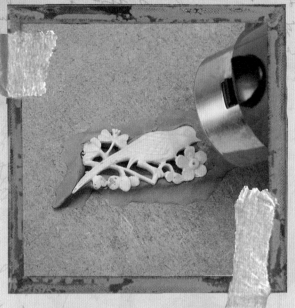

5. FUSE WAX

Heat the piece with a heat gun or hair dryer to really melt the wax down into all of the crevices, getting rid of the excess wax. Let dry.

6. BEGIN APPLYING SILICONE

Rub a thin layer (about $\frac{1}{8}$" [3mm]) of 100% white silicone caulking over the entire piece.

7. ADD MORE SILICONE

Let the silicone set for several hours, then rub another layer over the piece—this time about $\frac{1}{4}$" (6mm) thick. Let that set for a day, and then apply a thicker, final layer.

8. RELEASE MOLD FROM BOARD

When the silicone caulking is completely set, after another day, gently lift the piece off of the board.

9. PRY OBJECT FROM MOLD

Gently pull the original out of the mold.

10. CAST WITH RESIN

Mix up a batch of polyester fiberglass resin. This can be found at most auto parts stores and is a two-part resin. Mix according to package directions. Once mixed, pour it into the mold. Let it cure according to the package directions and then gently pull it out of the mold, starting around one edge and then carefully lifting it out of the mold. The resin will cure an amber honey color. I added a tiny bit of plaster to the resin mixture to achieve the creamy color (all by trial and error).

It will depend on the size of the item you are casting as to how much plaster you will add. If you want another color, you can add a tiny amount of oil-paint powdered pigment to the uncured resin before pouring it into the mold. It can also be painted with acrylics once it has cured, and can then be sealed with a clear acrylic sealer.

Clean the edges up with a file or a craft knife. Please follow manufacturer's safety instructions. For the record, I always make my molds outside, wearing gloves, goggles and a painter's mask.

11. BRUSH ON WALNUT INK

I like to age the piece a bit, so here I am brushing over the piece with concentrated walnut ink.

12. BUFF WITH RAG

Then, I brush off the excess with a rag.

AGING

I like to concoct mixtures that I can use to age fabrics, wood and papers. It takes the newness out of materials, giving them that forever-faded, lived-in look. Here are a couple of my favorites, but by no means are these the only ones I use. This is a fun, get-your-hands-dirty experiment. Try your luck with mixing acrylic paints with dirt, sand and gel medium, or maybe tea or coffee dips. One bit of advice, though: Write your recipe down as you are creating it. It's so easy to forget later how you achieved that perfect look!

WALNUT INK ON FABRICS

This is one quick-and-easy way to get beautiful stains.

1. DIP FABRIC INTO INK
Fabric, ribbon, scrim, cheesecloth or interfacing looks great dyed with ink. Dip it into the ink. Squeeze excess ink out and also work it through the fabric.

2. TWIST FOR VARIATION
To get some random aging, twist the fabric first.

3. DIP INTO INK
Then dip it into the ink. It's not necessrary to submerge the entire piece.

4. OPEN THE FABRIC
Squeeze out the excess. Unravel the fabric to reveal the aging.

GLAZE

What can I say? I've tried many brands and shades of glaze, and Ralph Lauren's Teastain never lets me down.

1. BRUSH GLAZE OVER WHITE

Starting on something that is painted a light creamy or white color, brush on a bit of the glaze. The more you use, the darker and more intense it becomes. Play around with it for the result you want.

2. DAB WITH RAG

Crumple up a bag or a rag and dab the glaze around.

3. DRAG WITH RAG

Or you can drag it to create grained texture.

COMPARE WITH INK

Walnut ink can stain light-colored surfaces or white paint, too.

MEDICAL TAPE

If you can find it, the cloth version as opposed to the synthetic version is the best to work with, because it grabs the paint or stain better—but don't pass up the nylon version if it's all you can find; it will work. Not only does it work as a secure tape, it adds a great surface to either paint on or write on with a permanent pen/marker. I have been known to gather it up, pleat-style and attach it to something else by hand-stitching it. It holds up better if you wait to distress it until after you've applied it to the surface. I like to use it as a frame around photos and memorabilia, or around edges to hold items together. Whenever I paint or distress it with, say, walnut ink, I give it a coat of clear sealer.

1. TEAR TAPE
I like to first tear the tape to fray the edge. It's a texture thing!

2. ADHERE TAPE
The tape can then be wrapped around something to add more texture or to actually secure something onto something else—in this case, a branch that will be secured to a box.

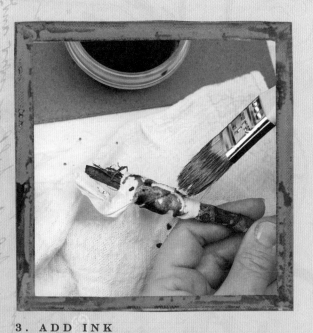

3. ADD INK
I then like to distress the tape to make it appear old, by dabbing on some walnut ink.

DISTRESS FIRST, APPLY LATER
The tape can also be distressed ahead of time, and then adhered or stitched to something. If the stickiness starts to fade, just secure it with a dab of glue.

SANDING

Sanding is a must-do when creating age—it takes the newness right off of anything from photos to papers to wood. A quick sanding around the edges is usually all it takes.

SANDPAPER
Sandpaper works great to age pieces of wood. Rub it over areas that would naturally receive extra wear, such as edges and corners.

ANTIQUING A MIRROR

I have collected vintage vanity mirrors forever, it seems. They are getting harder to come by, so I'd never break one on purpose, but I do have some that have broken by accident. I scoop the fragments up and save them for the perfect work. But for the sake of creating the look of those peely-edged mercury mirrors, I began distressing small ones that you can get at a craft store. These new mirrors have a thick coating that has to be removed for this to work, but, once removed, magic happens.

1. REMOVE SEALER
Wearing protective gloves, first remove the orange sealer from the back of the glass, using paint stripper.

2. SPRITZ ON ACID
Use a plastic spray bottle filled with muriatic acid to cover the remaining silver on the backside of the glass. Be sure to wash the bottle out thoroughly when finished, as this acid is highly toxic. Better yet, label it once you've washed it, and only use it for this muriatic-acid treatment. Follow all manufacturer warning labels! I wear heavy-duty protective gloves, goggles and mask when working with these dangerous products, and always outside!

3. DAB UP EXCESS
Let it sit for a bit to react, and then dab up some of it with a paper towel (or leave it). If you want to have more taken off, just spray on a heavier application. Experiment and have fun!

123

DÉCOUPAGE

Try not to pre-judge an item if you don't like its cover, so to speak! For heaven's sake, don't pass up a good core piece just because the color or design is all wrong. It can always be altered by découpaging it. I love the shape of these plastic birds but wanted to play up the idea of the songbird, so I knew that I wanted to add vintage sheet music to them. This is a great reminder when we find something new . . . but want to make it our own; we can do this by altering it.

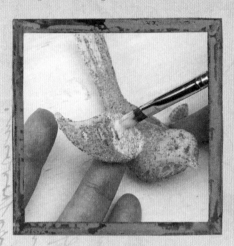

1. BRUSH ON MEDIUM
Tear vintage paper into strips or similar small pieces and adhere it to any object of your choice, using découpage medium.

2. BRUSH PAPER TOO
Brush medium onto both the paper and the object.

3. OVERLAP EDGES
Wrap paper around the edges, overlapping it in some places.

MODELING PASTE

This is another product that gets little attention, but gives big results in the texture department. I love to use it on wood pieces. It's a bonus texture that can be carved into, painted, stained and written into. Here, I used the end of a paintbrush to incise with, but I've used a nail, a paper clip or a stick—whatever I can lay my hands on in that moment!

It's also great to press an item into it that will leave an impression, such as a shell or a carving, an old chain, or a leaf—anything that has a raised design in it will work; just be sure to quickly rinse it off, or the paste will dry in the crevices—I learned that one the hard way! I spread it on like I am frosting a cake, then I smooth it out with an old plastic credit card or something similar.

1. SPREAD OUT PASTE
Spread a bit of the paste onto the surface using a credit card, and start spreading it around.

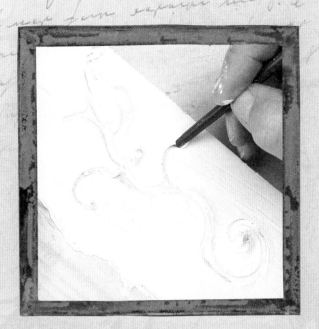

2. CARVE OUT MOTIF

Draw into the wet paste, using the end of a paintbrush or whatever tool you have handy.

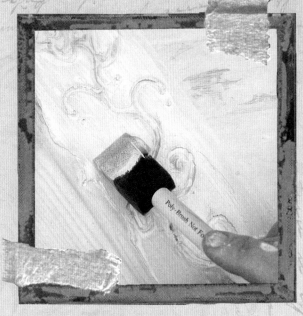

3. BRUSH ON PAINT

When the paste is dry, brush over it with a color to knock down the white a bit.

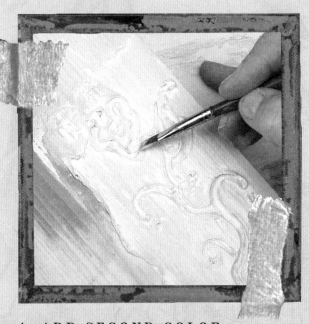

4. ADD SECOND COLOR

Add a second color over the first, lightly skimming the top— not a solid coat.

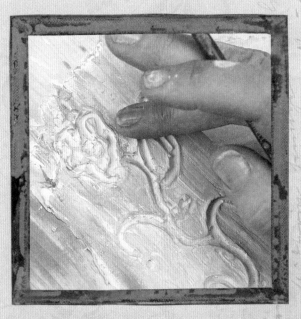

5. FINISH WITH RAW UMBER

When the paint is dry, you can antique it with a bit of watered-down Raw Umber paint (or, of course, walnut ink) in some areas.

INDEX

ANNIE LOCKHART

WHO IS ANNIE?

⭐ Well, for starters, and most importantly, she is a mom to five fabulous now-grown children. They are the loves of her life! She says nothing else even comes close, except being Nana to her four adorably cute-as-little-bugs grandchildren.

⭐ She is also a wife, daughter, sister, friend and auntie, finding immeasurable, never-ending joy in each of these soul-stirring, memory-making relationships.

⭐ She is an explorer of life. She loves to linger near the ocean, listen to good soulful music, dance like no one is watching, and photograph life, unscripted. She loves writing, wildflowers, reading, and finding that empty space. Annie is forever embracing the people that cross her path, and, always the student, she is ever learning as new discoveries present themselves. She is grateful beyond measure for the lessons and rich layers of life she has lived so far.

⭐ In keeping with the true nature of this book and her life as an artist, Annie has shown and sold her artwork in national juried art shows. She has also had her artwork featured in several magazines. Annie enjoys teaching at artist retreats throughout the country. And last but not least, she quite happily adds Gypsy Gatherer, Curious Collector and Junkyard Junker to her repertoire.

INDULGE YOUR CREATIVE SIDE WITH THESE OTHER F+W MEDIA TITLES

SECRETS OF RUSTY THINGS
MICHAEL DE MENG

Learn how to transform common, discarded materials into shrine-like assemblages infused with personal meaning and inspired by ancient myths and metaphors. As you follow along with author Michael deMeng, you'll see the magic in creating art using unlikely objects such as rusty doorpulls, old sardine tins and other quirky odds and ends. This book provides easy-to-follow assemblage techniques, shows you where to look for great junk and provides the inspiration for you to make your own unique pieces.

ISBN 13 978-1-58180-928-2
ISBN 10 1-58180-928-X
paperback, flexibind with flaps
128 pages
Z0556

SEMIPRECIOUS SALVAGE
STEPHANIE LEE

Create clever and creative jewelry that tells a story of where it's been, as metal, wire and beads are joined with found objects, some familiar and some unexpected. You'll learn the ins and outs of cold connections, soldering, aging, using plaster, resins and more, all in the spirit of a traveling expedition.

ISBN-13 978-1-60061-019-6
ISBN-10 1-60061-019-6
paperback
128 pages
Z1281

These books and other fine North Light titles are available at your local craft retailer, bookstore or online supplier, or visit our Web site at *www. mycraftivitystore.com.*

CREATIVE AWAKENINGS
SHERI GAYNOR

What if you could unlatch the doors to your heart and allow yourself to explore hopes and dreams that you haven't visited for a very long time? *Creative Awakenings* is the key to opening those doors, showing you how to use art making to set your intentions. Creativity coach Sheri Gaynor will be your guide through the mileposts of this exciting journey. You'll learn how to create your own Book-of-Dreams Journal and a variety of mixed-media techniques to use within it. A tear-out Transformation Deck will aid you in setting your intentions. You'll also get inspiration from twelve artists who share their own experiences and artwork created with the Art of Intention process.

ISBN-13 978-1-60061-115-5
ISBN-10 1-60061-115-X
paperback
144 pages
Z2122